Art *of the* Pencil

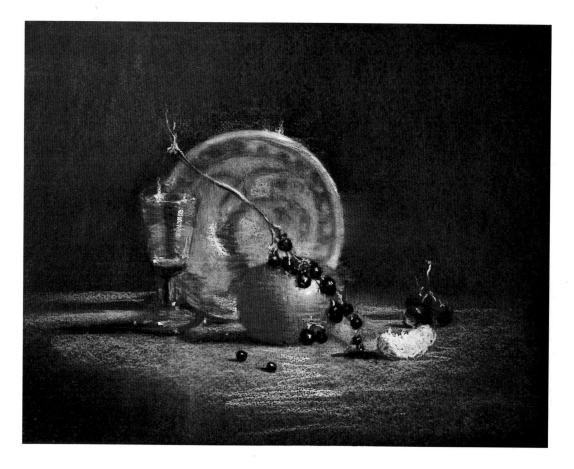

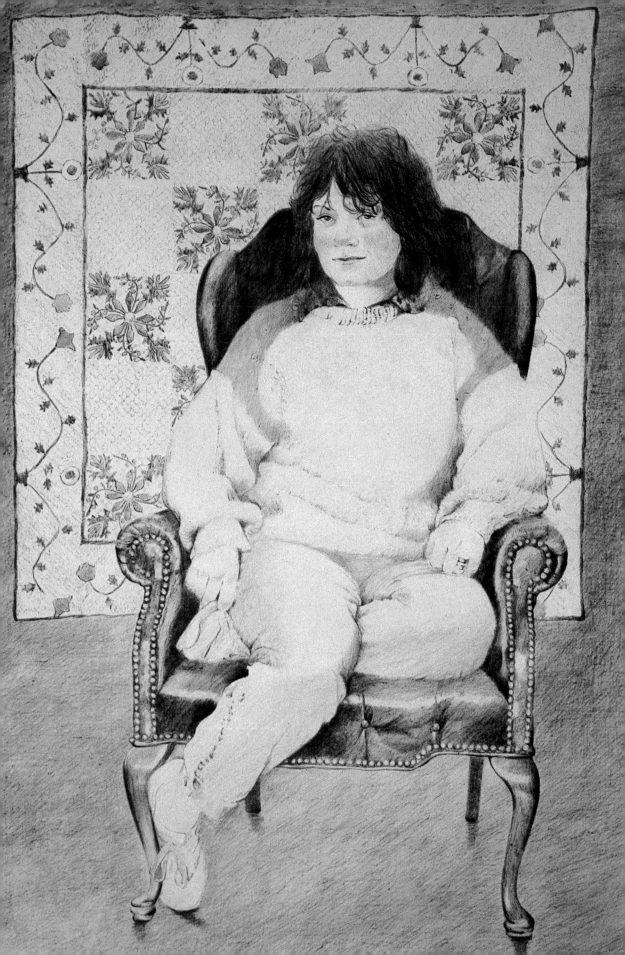

Art *of the* Pencil

A Revolutionary Look at Drawing, Painting, and the Pencil

Sherry Wallerstein Camhy

WATSON-GUPTILL PUBLICATIONS/NEW YORK

This book is dedicated to Helen Wallerstein Meyer.

Cover: WHITE FLOWER
Water-soluble pencils and crayon on mounting board,
$20^{1}/_{2} \times 14$" (52×36 cm).

Half-title page: STILL LIFE
Pastel pencils and soft pastel on paper, 16×20" (41×51 cm).

Title page: SUSAN'S SISTER
Graphite and colored pencils, 36×32" (91×81 cm).

Senior Editor: Candace Raney
Edited by Robbie Capp
Designed by Areta Buk
Graphic production by Ellen Greene
Text set in Caslon 540 Roman

First published in 1997 by Watson-Guptill Publications,
a division of BPI Communications, Inc.,
1515 Broadway, New York, N.Y. 10036

Library of Congress Cataloging-in-Publication Data
Camhy, Sherry.
 Art of the pencil : a revolutionary look at drawing, painting, and
the pencil / by Sherry Camhy.
 p. cm.
 Includes index.
 ISBN 0-8230-1373-1
 1. Drawing—Technique. I. Title.
NC730.C24 1997
741.2—dc21 97-22486
 CIP

Manufactured in Italy

First printing, 1997

1 2 3 4 5 6 7 8 9 / 05 04 03 02 01 00 99 98 97

Contents

Introduction

When I was beginning to study art, like most students at the time I was told to learn drawing before learning painting. After years of working with both pencil and brush, I discovered how much I disagreed with that premise.

Fate played an unexpected role in that discovery. There were two hundred acres of forest behind my home until a builder began to clear the land by sawing down all of the trees. The noise was unbearable from dawn to dusk every day. So I used that as an excuse to do what I really had wanted to do all along: go back to art school. Every morning I painted and every afternoon I studied figure drawing. To my surprise, painting helped my first love, drawing, in ways I would never have guessed possible. I realized how both painting and drawing deal with the concepts of values, edges, massing, light, planes, and composition. In this book I would like to share with you what I have discovered about seeing drawing and painting not as totally separate entities, but as ideas that overlap and merge to create images and ideas that can and do work together.

Van Gogh drew with a paintbrush.
Seurat painted with charcoal.
Cézanne combined both. Try it!

Vincent van Gogh drew with a paintbrush. Georges Seurat painted with charcoal. And Paul Cézanne wrote:

"This hair, this cheek, they're drawn, that's easy; there, these eyes, this nose, they're painted . . . and in a good picture, like the ones I dream about, there's a unity. The drawing and the color are no longer distinct; as one paints, one draws; the more the colors harmonize among themselves, the more precise the drawing becomes. That's what I have learned from experience."

BECOMING AN ARTIST

Drawing, painting, and combining those concepts are skills that can be learned, practiced, and conquered. Some of the process has to do with how we use our eyes to interpret our perceptions graphically, and some of it has to do with how we use the materials available to us. This book deals with both concerns. We will cover a range of media, some of which may be used both dry and wet: carbon and its graphite and charcoal derivatives; chalk-based materials

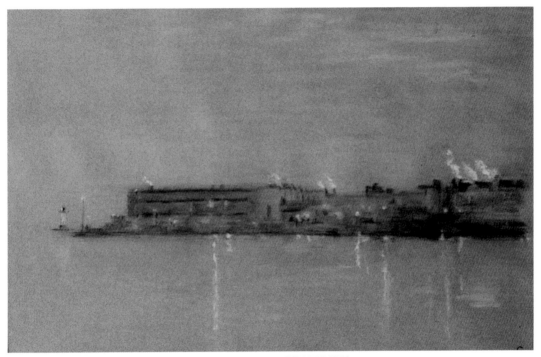

THE GENERAL ELECTRIC PLANT
Water-soluble pastel pencils and soft pastels on paper, 14$\frac{1}{2}$ × 18$\frac{1}{2}$" (36 × 46 cm).

I created this on cream-colored pastel paper torn from the corner of an unsuccessful portrait. I would not have used this kind of surface with water because it tends to buckle, but at the time, I had no choice. It was started on the George Washington Bridge, and it was the only paper I had in my car. The light on the building was so beautiful that I pulled over, grabbed my pastel pencils, and started working. There was very little traffic on the bridge, and then there seemed to be none. Suddenly, police cars were all around me. They thought I was going to jump. I explained that I was an artist—but they still made me move on. At home, I took a small sable brush and a drop or two of water and finished what I had begun. With the paper still damp, I used the softest white pastel I could find, a Sennelier for the smoke and the light on the water.

such as pastel; and waxy media like colored pencils and crayons.

From the first cave paintings to the canvas that is still wet, artists have dealt with many of the same issues and problems, often breaking the "rules" to invent different ones. You are part of that tradition. I hope that you enjoy the process of learning, the fun of doing. When you experiment with pencil techniques that are new to you, suspend negative judgments. If you focus on the success or failure of each piece of work you create, it will get in the way of learning. Even a successful artist like David Hockney acknowledges that "if you're going to experiment, you must expect failure." There will be good days and bad days, but if you keep practicing, even what you consider weakest in your work will improve—and tomorrow's creative effort might be the best yet.

Artists are magicians who have the skill to create illusions that surprise, awe, and delight viewers. My goal is to let you in on some of the secrets of how artists do it so that you can do it, too.

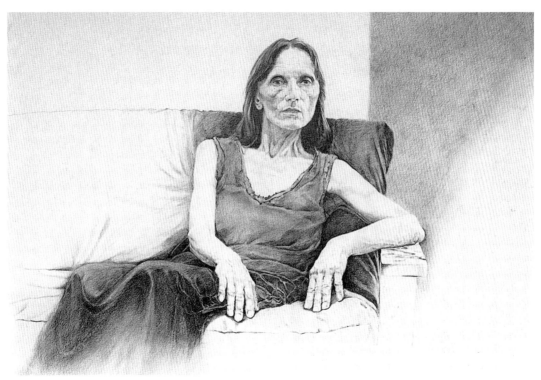

NINA IN THE STUDIO
Graphite pencil on paper, 42 × 60" (107 × 152 cm).

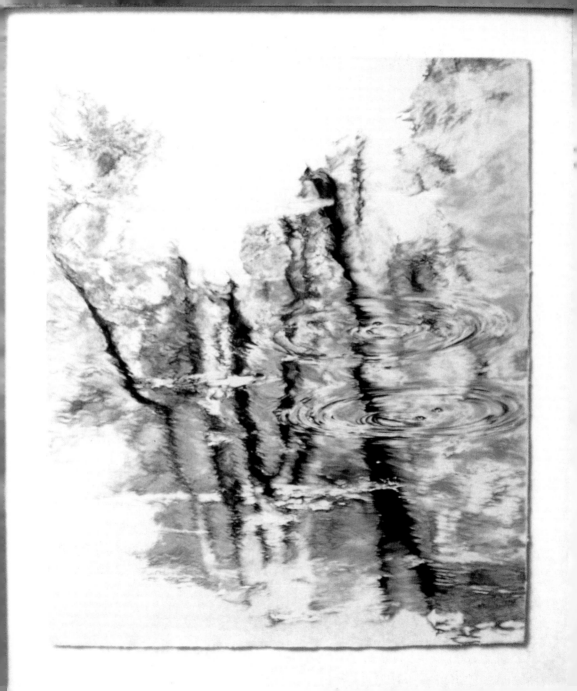

Chapter 1

Drawing, Painting, and the Pencil

Do you remember your first pencil? Mine was yellow. It was the first thing I drew with, scribbling and making "pictures" long before I learned to write. A pencil was a precious thing to me then and it still is now. I have grown to respect its elegant simplicity, its impressive tradition, and its expressive potential.

In the computer age, there is something pure about the beauty of an image created with a simple pencil. Toulouse-Lautrec said, "I am a pencil." While every medium has its possibilities and I enjoy experimenting with them all, I will never be without my pencil. It is quiet, clean, odorless, inexpensive, and lightweight. I can slip it in my pocket and take it with me everywhere—my secret friend.

This chapter is about using pencils in new ways. The very position of a pencil in your hand greatly influences the kind of marks you can make. Many pencil positions are illustrated in the pages ahead.

But first, we will explore the history of drawing and the traditional differences between drawing and painting techniques, then how they merge and expand into new artistic avenues for you to travel.

AT A STILL POINT
Oil on canvas, 41 × 36" (104 × 91 cm).

What is a drawing? What is a painting? I left large areas of this oil painting white, tore the canvas from its stretcher to give the edges the ragged look of deckled, handmade paper, then framed it floating under glass like a drawing. I wanted people to think about whether it was a drawing or a painting.

The History of Drawing

The verb *draw* is from the Old English word *drag*, suggesting that the first drawings were done by dragging a stick across the ground or its burnt end across a cave wall. The earliest known drawings date back at least thirty thousand years to the Paleolithic art found on cave walls, such as the famous images discovered at Lascaux, France. Was there art before that? No one knows when, why, how—or who first began to draw. Classical myth tells us that art was invented when Cupid guided the hand of a Corinthian maid as she traced the shadow outline of her sleeping lover's profile on a wall. Mythology aside, mark-making probably began before the development of language, and certainly before the written word. Just observe how babies delight in the marks they can make long before they can speak intelligible words or read or write them.

Artists have always been fascinated by the magical qualities of drawing. We draw for the pleasure of doodling, to remember what we have seen, and to explore new ideas. Drawing has been used as a way of investigating the visual world and recording discoveries. During the Renaissance, drawings began to be valued because they revealed the thinking of the artists and inventors of the time. By the seventeenth century, guild artisans thought drawing was more important than painting because it was at that stage of development of a work that the idea of the image and the difficult problems involved in it were resolved. Then, the painters simply had the job of preparing and applying the color. A credo of the age, "line over color," was partly responsible for the separation of the concepts of drawing and painting and the confusion that followed in its wake as the history of art moved on.

It was not until the late eighteenth century that artists began to consider drawings as worthy of exhibition. Only then did gallery owners, critics, and collectors reconsider drawings as works of art unto themselves.

DRAWING TODAY

In an article published in *Architectural Digest* entitled "Painters' Drawings," Robert Rosenblum wrote, "As collectors and connoisseurs have known for centuries, in drawings we may feel privy to the artist's initial impulses . . . drawings take us behind the scenes, often putting us closer not only to the artist's hand but even to the artist's heart." Perhaps that is why museums now mount entire exhibitions dedicated to the drawings and sketchbooks of artists as far separated by time and style as Leonardo da Vinci (1452–1519) and Henri Matisse (1869–1954).

Contemporary artists are rethinking the form, function, process, and meaning of drawing. Drawings are no longer necessarily smaller than paintings. In Leonardo's time, paper was precious and drawings were small. Today, huge sheets of paper make it possible to work on a very large scale. Artists join many pieces to make a grid of drawings that form an image to cover an entire wall. Drawings are also no longer thought of only as preparations for paintings. Jasper Johns makes drawings of paintings he has already completed, reversing the usual order of working. Those drawings, in turn, are frequently the inspiration for other paintings, bringing the process full circle.

Technology has also had its impact on drawing. Photographic images are being incorporated into drawings. The first simple metal stylus has evolved into one connected to a sophisticated computer. A drawing can be scanned into a computer or created directly on one by using software programs like Photoshop or Illustrator. The possibilities are infinite, as artists reconsider, expand, and redefine drawing.

What Is a Drawing? What Is a Painting?

Definitions of "drawing" and "painting" tend to raise more questions than they answer. One dictionary tells us that drawing is "a graphic representation by lines of an object, as with a pencil delineation of form without reference to color." But obviously, that overlooks numerous drawings that *are* in color.

Another source defines a drawing as "a work on paper"—but that excludes not only cave drawings of the distant past, but also contemporary drawings being rendered on canvas and on other surfaces, as well as the more controversial art forms of our day that comprise drawings created on the ground and even in the air.

A third source sees drawing as an outline that describes a form or shape. But while marks made by a stick in sand, a diamond on glass, a chisel on stone, an awl on ivory, or chalk on a blackboard can all be considered drawings, another instrument that can be dragged over a surface, leaving a mark behind, is a brush wet with paint. What about works in which a brush is used to create a linear image? Are they drawings or paintings?

I find all the definitions above to be too narrow or too wide to be definitive, but they do indicate some of the criteria traditionally used for dividing works of art into one category or the other. Those criteria can be easily summarized.

TRADITIONAL CRITERIA

Distinguishing drawing from painting usually takes into account the medium and surface used, the method of application, how much surface is covered, how color is used, whether the pigment is wet or dry, and how lines or shapes are expressed. When drawings are considered as works on paper, then images on walls, canvas, and other surfaces are excluded, but watercolors, pastels, oil, or acrylic paintings done on paper are included. Graphite and charcoal can be and often are used on canvas. Does that make those drawings or "paintings"?

On the other hand, if a painting is just black on white or just white on black, is it a drawing? How should we classify artwork made on toned paper with colored pencils, pastels, and oil sticks that can be liquefied with turpentine or water and used like paint? It seems to me that the essence lies in redefining and overlapping the two disciplines.

Water-soluble colored pencils can be used dry or wet, with brush.

Combining Drawing and Painting

More and more we see contemporary artists disregarding rigid classifications. Jasper Johns dissolves powdered graphite in lighter fluid to make tones of gray that he uses like watercolor washes or oil glazes. Larry Rivers, Leon Golub, and Francis Bacon all leave large areas of huge canvases unpainted—defying the "rule" that only fully covered surfaces are considered to be paintings. David Hockney entitled his exhibition of photo-collages "Drawing with a Camera" because, he said, "it seemed to me that it was more about line than anything else." The nature of drawing and painting is being expanded more than ever before, although we can learn from previous masters' explorations as well.

THE IDEAS OF COROT

Jean-Baptiste-Camille Corot (1796–1875) wrote in 1830, "It is very useful to begin by simply drawing one's painting on a white canvas." The term *drawing* was being used to describe the process of exploring the idea, placement, proportion, and composition of a work of art. His use of the word comes close to revealing the crux of the matter.

Drawing has to do with the creation of the idea of the work and with understanding and resolving the proportions of the forms chosen and their relationships within the picture. Before the twentieth century, drawing was regarded primarily as the beginning, preparatory stage of a work and painting the final result.

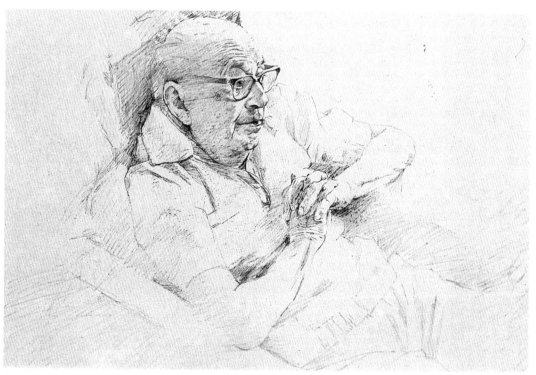

MR. GEORGE STERN (DETAIL)
Graphite pencil on Fome-Cor, 10 × 30" (25 × 76 cm).

Laminated board (Fome-Cor) is not the best surface to use with pencil, but it was handy when I wanted to capture just this moment in a rapid sketch, using line to build areas of tone.

THE IDEAS OF CÉZANNE

By the early 1900s, Paul Cézanne (1839–1906) had raised some basic questions about the relationship of drawing to painting. He did not think that the idea of an image could be separated from its execution. A drawing could not contain the concept if paint was necessary to complete the thought. A painting was the translation of the idea into a totally different language. The beginning and the ending of the idea needed to be merged. "Drawing and painting are no longer different factors; as one paints, one draws," Cézanne declared.

Cézanne, like Corot, used the word *drawing* to mean the first marks an artist uses to lay out what will go where in the painting. Drawing was thought of as the structural armature, as the beginning of an image to be built on and to become an integral part of a painting as it evolved. A drawing was no longer considered as an outline to be filled in with paint. "Drawing" is the basic idea and it is an organic part of the process of painting.

When an artist completed the statement of his idea, his image—whether a sketch or a painting—was a finished work of art. Cézanne's thoughts gave drawing a new dignity. A painting could now be considered finished even if much of the canvas remained untouched. A painting could be a sketch done with oils. "The more the colors harmonize among themselves, the more precise the drawing becomes," Cézanne wrote.

So now we ask: If an artist can draw while painting, can an artist paint while drawing?

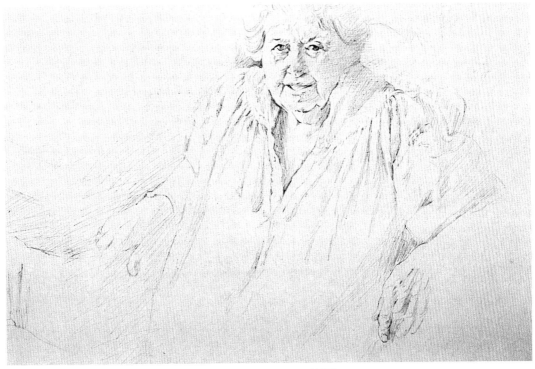

MRS. ANNIE STERN (DETAIL)
Graphite pencil on Fome-Core, 10 × 30" (25 × 76 cm).

In a rapid sketch such as this, tone added selectively lends a quality of animation to the image.

New Ways to See Drawing and Painting

According to *The Thames and Hudson Dictionary of Art Terms*, something is said to be "out of drawing" when it is simply not right, "when the representation in two dimensions does not reconstitute itself, in the spectator's eye and mind, into a convincing three-dimensional form."

"Well drawn" indicates that there is nothing that feels wrong in the work. A "good draftsman," to use a term borrowed from the field of drafting, is an artist who is skilled at getting it right. But that assessment places too much emphasis on correctness. "Right" doesn't necessarily lead to effective, sensitive, expressive, or beautiful art, nor can it be applied in the same sense to images that are not representational or figurative.

Once again, it seems to me that we need to set aside past definitions and establish new ones that apply to the art of the pencil as distinct from, and also as a companion to, the art of the brush. But unfortunately, when we want to specifically designate one who draws, our language lacks a term comparable to *painter* or *sculptor*—the word *drawer* may be awkward, but the concept is crucial.

PAINTERLY VERSUS "DRAWERLY"

Painterly is a word that also has no equivalent in discussing the art of drawing. Perhaps "drawerly" might be used, although it's hard to articulate. In discussing drawing, we're not talking only about draftsmanship, "getting it right." There is much more to the art of

HUDSON RIVER WINTER
Graphite pencil on paper,
16 × 22" (41 × 56 cm).

Although this was created with pencil on paper, I consider it a painting of wintry white and silvery cold. The river was so beautiful that I couldn't resist parking in an emergency area, leaving my engine running for warmth and the window open for a clearer view. I had my sketch pad, pencils, and lovely radio music playing. What else could an artist want? I knew my painting needed a center of focus but I wasn't sure just what it would be— then the solitary runner appeared.

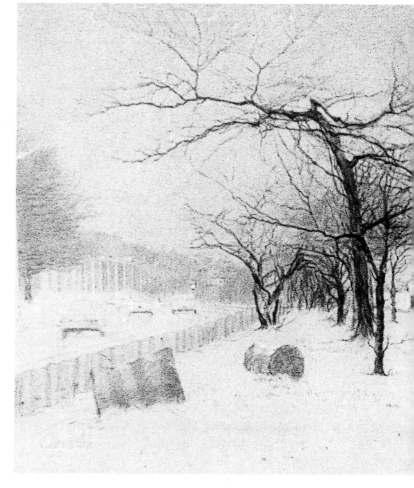

drawing than that, and here is where drawing and painting can be seen as first cousins. As artists drawing, we are concerned with the form, content, and subject matter of our work. As artists painting, we often concentrate on the kinds of lines we make. In other words, our drawings can be painterly, and our paintings can be "drawerly."

Material distinctions—that pencil and paper are exclusively for drawing and paint and canvas for painting—no longer apply. I think the differences that separate the two art concepts can be traced to the different thought processes and perceptions that govern our approach to drawing and painting styles. I believe that an understanding of this process will help in your development as an artist.

VISUAL PERCEPTION

Drawing is touching something from afar; it is making marks; it is tactile. It is usually thought of as linear. *Linear* is the term most often contrasted to painterly, but the difference between drawing and painting is much more than whether or not lines are used. The difference is connected to how we process visual and tactile information.

We can see from birth, but what do we perceive of what we see and when do we make sense of it all? The world around a newborn expands gradually as the baby fixes on people and objects, studying the effects of light and perspective, distance and nearness, discovering that things are bigger when they're closer and much easier to see. The visual clues the baby is studying are the same ones that the artist uses in a painterly image to create the illusions of form on the picture plane, translating the flat surface into forms that appear to have three dimensions.

Of course, in our daily activities, our lives depend on the speed and accuracy of our three-dimensional vision as we constantly judge distance and direction, when we reach out to touch someone, or cross the street, or park the car—making automatic visual decisions based on nonverbal thinking.

Try this experiment. Close your left eye. Point your finger at the edge of an object. Keep your finger there. Now open your left eye and close your right eye. Your finger seems to jump to the right, revealing much more of the object.

While each eye sees a slightly different view of the same object, our brain merges the two images into one, giving the illusion of three dimensions. We don't see an outline around the edges of a shape. We sense a volume turning away from us and continuing behind, and although we no longer see it, we know it exists.

FROM VISUAL AND TACTILE TO WORD PICTURES

Once infants discover their own hands, learning changes. They explore their world by grabbing things, learning in a tactile way. Infants constantly use the right side of their brain, the nonverbal side, to gather the raw data that the left side of the brain, the verbal side, will use for the simplification process to categorize and name things.

As babies explore their world, objects begin to have names. An apple is an apple whether it is big or small, red, yellow, or green. Soon an apple can also be recognized as a symbol, a round shape outlined in black with a short line for a stem, as seen in a book full of brightly colored pictures.

After babies enjoy the lovely smears they make with puree of prune on their high-chair tray, when they make their first attempts at scribbling on paper, they just try to hit the surface. Later, they are able to control where on the page the crayon will land. Studies in the development of children's art consider this stage the first exploration of placement and composition.

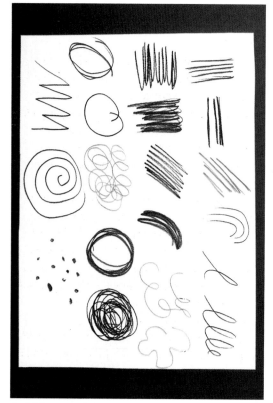

Scribbling reveals a person's personal mark-making style. We each have our very own graphic handwriting. Of these twenty typical scribbles, which ones are most like yours? Can you think of any others?

Our earliest experiments become part of our artistic vocabulary and echo like a recurring melody throughout our creative development.

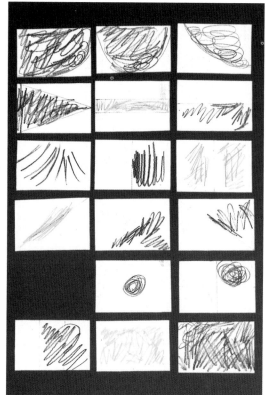

These are typical placement patterns in the drawings of young children. When a composition fills a page and an artist establishes a center of interest, often it is one that stems from his or her earliest childhood drawing patterns. As you glance through this book, you can see that my favorites are the use of the diagonal, a simple central placement, or an accent in the right, lower third of a horizontal format. What are your favorites?

MASSING AND PLACEMENT

When children's scribbles become an organized attempt to fill a space with an object, there are no lines around the object. It has an implied shape with no outlines. These early pictorial images are made up of individual placement patterns, techniques of mark-making and scribbling, the shapes and basic designs that are now part of that young artist's aesthetic vocabulary. But it is not long before that creative instinct collides with adult expectations and the need for approval as children try to paint images that others will recognize. The kindergarten child proudly brings home pictures of the sun, a house, a flower, a rocket ship, a robot, drawings that rarely look "real." In a sense, they are not derived from what the child really sees. The sun will probably be a circle with straight lines all around for light rays; everyone will know what it is. Each shape is usually a clearly outlined, separate form, characteristic of verbal thinking, an approach that is also very commonly used by adults in their first life-drawing class when they begin by trying to put outlines around the figure to separate the model from its environment.

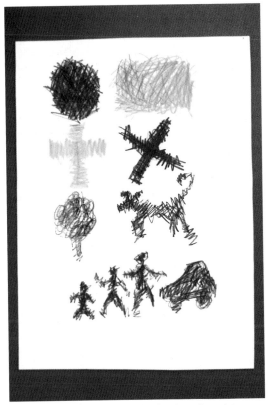

Massing evolves when scribbles begin to form into shapes. Some are unidentifiable; others are readily understood as geometrics, figures, animals, cars, and other familiar objects.

DRAWING GUIDED BY NONVERBAL THINKING

Once in a while, a child seems to be gifted with the natural ability to draw everything just the way it really looks. That child is not necessarily more talented than any other. That child is simply drawing what he or she sees with the right, nonverbal side of the brain.

I met such a young woman at art school. She drew beautifully, and no matter how the model posed, she always got it right. When I asked her how she did it, she smiled and said, "I just put down what I see." While I and others drew what we thought we *should* see, using symbols for eye, nose, and mouth— she drew shapes and shadow patterns, working with the right, visual, nonverbal side of her brain. I had to learn to find mine.

Our tactile and visual senses provide us with different kinds of information. I believe that the differences between these two sources is what distinguishes a drawing approach from a painting approach to art. Drawing is related to verbal, tactile symbols; it is usually the mode employed when working from imagination. Painting is nonverbal and visual; it is usually the mode employed when working primarily from observation.

Drawing Versus Painting Techniques

The thinking process related to drawing traces to our sense of touch. When we hold a pear, our fingers are aware of its outside surface; it is an independent, solid shape, and a group of pears is a collection of equally important, individual shapes.

Painterly thinking relates to our sense of the visual. We view the pear as part of a group; we notice how the light falling on them affects their visibility, their color. The pear is seen as part of the whole, the bigger picture.

The thinking that drives these two different approaches affects the choices made by artists in the way they handle lines, edges, light, color, detail, and composition.

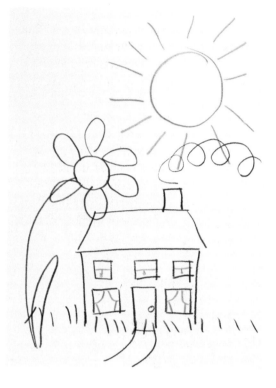

This sun, flower, and house are examples of word pictures. Somewhat akin to Egyptian hieroglyphs, these simple line drawings are symbols of the objects they represent; art based on conceptualization, as opposed to observation.

4 PEARS
Graphite and
colored pencils
on paper,
9$^{1}/_{4}$ × 12$^{1}/_{2}$"
(23 × 32 cm).

From left to right: The first pear is massed in; the second is outlined—it is a symbol of a pear; the third is a contour drawing, a continuous line moving across the form as well as around its outside edge; the fourth is a silhouette.

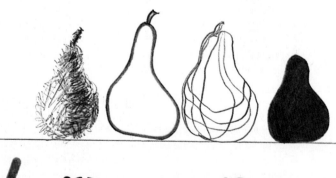

LINES

Lines do not exist in nature; there are no lines around anything we see. We make them up to indicate the edges of objects or to separate areas of color, value, or form from one another.

In drawings, although tone and color are sometimes used, the emphasis is on the aesthetic quality of the line. Using lines to separate an object from its environment is a fundamentally tactile concept. Line is also used to divide the surface of the work into decorative positive and negative areas and to guide the eye from one shape to another. Each line is significant in itself. Its uninterrupted delineation can be used to indicate things as ephemeral as smoke or clouds or water.

In a painterly style, lines have a very different feel and function. They no longer necessarily follow the tactile edges of things but are massed together to develop areas of tones, forms, or shadows. Contour lines move from thick to thin, from dark to light, from hard to soft. Lines appear and disappear, come closer and move away, move in and out of the surface or the picture plane. They depict texture. All of these effects can be achieved with a pencil just as well as they can with a brush.

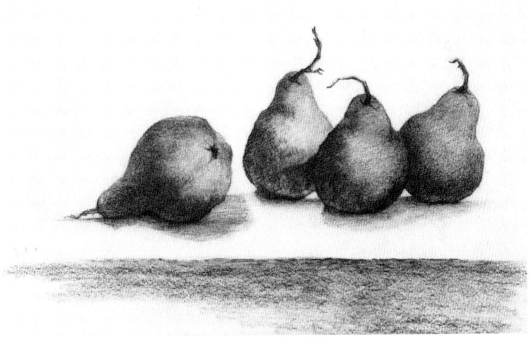

STILL LIFE WITH PEARS
Graphite pencil on paper, $11^1/_2 \times 14^1/_2$" (31 × 36 cm).

I arranged these pears carefully so that each outside shape would form an interplay with the next, moving the viewer's eye across the composition from left to right. Once I had sketched in the basic image, I used a 2B pencil for both lighter tones and darker shades.

EDGES

To use the pear as our example once again, if a pear is half in shadow and some of its edges are not visible against a dark wall, the artist who tends toward a linear style will define the outline of the pear, even if it cannot actually be seen. The background might be changed to a very light value or a contrasting color.

Using a very different approach, a painterly style of the same pears would let the edges of one merge with another where they disappear, because putting down what you see also means leaving out what you cannot see. If line is used at all, it would be as a crisp accent. Edges would be softened to indicate that we see around form.

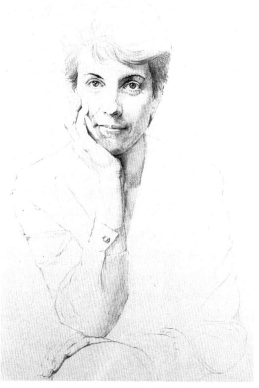

STUDY OF MARTHA BOUVIER
Graphite pencil on paper, 26 × 19" (66 × 48 cm).

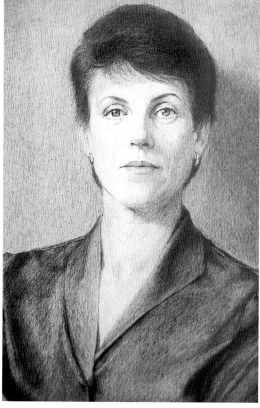

PORTRAIT OF MARTHA BOUVIER
Graphite pencil on illustration board, 30 × 24" (76 × 61 cm).

Although this delicate and airy portrait of my friend Martha is not truly a linear image, much of the study uses line to move the eye from one area to another. The value range is limited, drawn with hard (2H, 3H, and 4H Derwent) graphite pencils on smooth (Strathmore plate-finish) paper. Very hard pencils applied exclusively, with minimum form shading, produces a look reminiscent of a drawing technique of the Middle Ages known as silver point, the use of a silver rod on a surface prepared with white pigment.

While this study is complete, there is a lot that is deliberately undefined because I wanted to show Martha flooded with light, looking forward, facing life directly, bravely, positively.

This portrait is a tonal, painterly study. It is Martha in a very different mood from that shown at left. I used seven Derwent B-series pencils, ranging from HB to 9B, and a 5B Berol Turquoise on medium-finish illustration board. Its surface texture was helpful for creating the background atmosphere and texture of the silk blouse, but its rough finish was a challenge to keep Martha's complexion looking fine and smooth. The pencil's graphite was burnished—rubbed heavily into the fibers of the illustration board—to give Martha's hair a dark shine. The Berol Turquoise 5B helped make that possible because it is slightly more waxy than the Derwent brand of pencils.

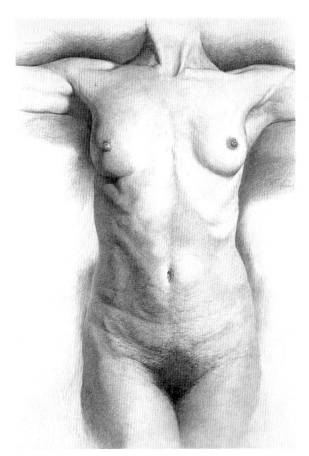

TORSO SERIES: CHRISTA
Graphite pencil on paper,
37 × 27" (94 × 69 cm).

This figure study and the one below are examples of two different ways to handle edges. Both were drawn on smooth printing paper with 3H and 4H pencils in the lighter areas, HB and 2B for medium tones or transitional edges, and 2B through 9B Derwent pencils for the darks. Although I used the same assortment of pencils for the two torsos, the darker values are stronger and more dominant in this one. In both studies the internal forms are rendered with care and the figure's outside edges are equally emphasized, but here, the edges of the figure are pushed forward and pulled back by the relationship of darks and lights adjacent to them. My goal was to achieve a feeling of potential movement, but to leave its direction ambiguous.

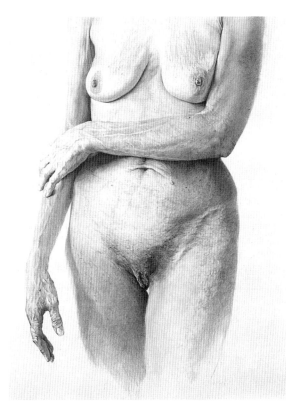

TORSO SERIES: NINA
Graphite pencil on paper,
37 × 27" (94 × 69 cm).

Although this figure is modeled in great detail, the form stops at the outside edges. The subject is isolated from her environment, as opposed to the connection between figure and background in the companion study shown above.

I tried through this study to make a statement about the internal by portraying the superficial. Nina is a poet who lived in Siberia for many years. Her difficult life there aged her body and hands well beyond her years, but never defeated her quiet courage, internal strength, and self-containment.

LIGHT

When setting up a still life or lighting a model for a figure portrait, a bright, even light that makes the subject stand out clearly from its background is the choice of the artist concerned with the sculptural, tactile effects that I have described as a drawing approach. Light and shade can explain the shape of the form, whether those effects are visible or not. Using a single source of light coming from one side and slightly above helps to define form in the clearest way possible.

The artist in love with visual, painterly effects usually prefers a smaller spotlight with a more intense source of light to increase the contrasts between light and dark and cause more shadow patterns in which forms appear and disappear from view.

For example, if a baseball is placed on a windowsill, bright light flowing in from behind it will make it look like a solid, dark silhouette. Sometimes the sun is so intense that a halo of light flows around the outside edge and creates what is called rim lighting. Our eyes see a startling pattern of brilliant light and dark. A painterly approach, with brush or pencil, would try to replicate that visual illusion.

Our sense of touch gives us a very different goal. To depict a hard, round baseball and emphasize its tactile qualities, we may alter the light to show the ball's outline to best advantage, such as moving a lamp directly to the front of the ball. Off to one side, the lighting setup would accentuate the form's volume.

If it's impossible to alter lighting or if you're attempting to work from imagination, you can create sculptural shading by imagining front lighting, by shading the form so that it grows gradually darker toward its outside edges. But observation is the best teacher, and form lighting, also called "Rembrandt lighting" to honor the great master's brilliant use of natural north light, is the most revealing way to see and learn about form.

In bright, evenly distributed light, each object is clearly defined and easily discernible as a separate entity isolated from its environment. Light emphasizes the tactile, sculptural qualities of every form. Each color can be seen closest to its true state in diffuse, neutral light. This use of color is linked with the concepts of drawing. Raphael, Michelangelo, and Ingres use this kind of lighting and color in their paintings.

NATALIE AURA ZUCKERMAN
Graphite pencil on paper,
16 × 20" (41 × 51 cm).

A Derwent 2H pencil on smooth paper produces enough depth of value to define forms, and yet contains enough clay to impart a gentle silver color that keeps the shading delicate, as in this portrait.

Babies make very challenging portrait subjects with rapidly changing expressions that are full of potential. To capture likeness and turn a generic baby face into a unique face, give close observation to the specific details of lips and eyes and the shape of the bone structure of the forehead and the nose.

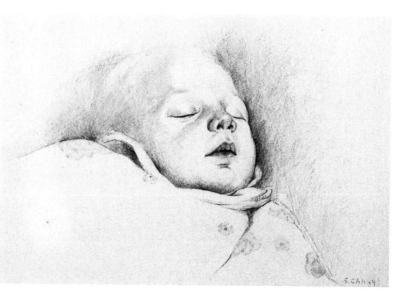

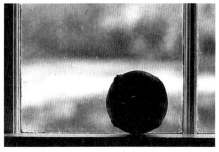

Back lighting: The light coming in through the window causes the round, white baseball to look like a flat, black silhouette, with no interior detail.

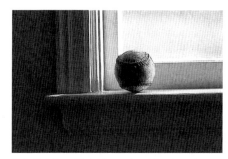

Side lighting: Light from the side gives the form another dimension. It gives clarity to the internal edge, the turning place where the light stops and the form shadow begins.

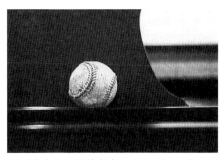

Front lighting: With light coming from the front against a dark background, the baseball becomes a flat, white shape, with just a little shadow defining its contour at the bottom.

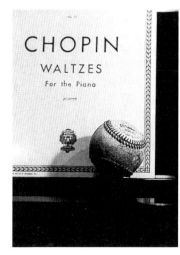

Light from upper right: Moving the ball in front of a lighter background reduces the contrast, making the ball look less bright. The cast shadow falling on the sheet music to the left of the baseball makes it obvious that the illumination is now coming from the upper right.

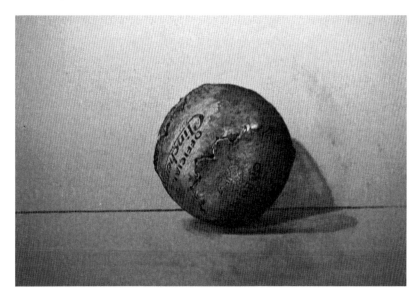

MY OLD BASEBALL
Graphite pencil on illustration board, 18 × 24" (46 × 61 cm).

The light from upper left hits the ball, which blocks the light from falling on the countertop behind and under it, causing cast shadows on both surfaces. Cast shadows have crisp edges near the object and softer ones as they move away from it. A single light source creates one cast shadow; several sources of light produce many.

The lettering and its value echo the light and shade on the form. It is crisper, darker, and more distinct against the skin of the ball in the light. The stitching helps to define its shape, further catching light where it is raised off of the surface.

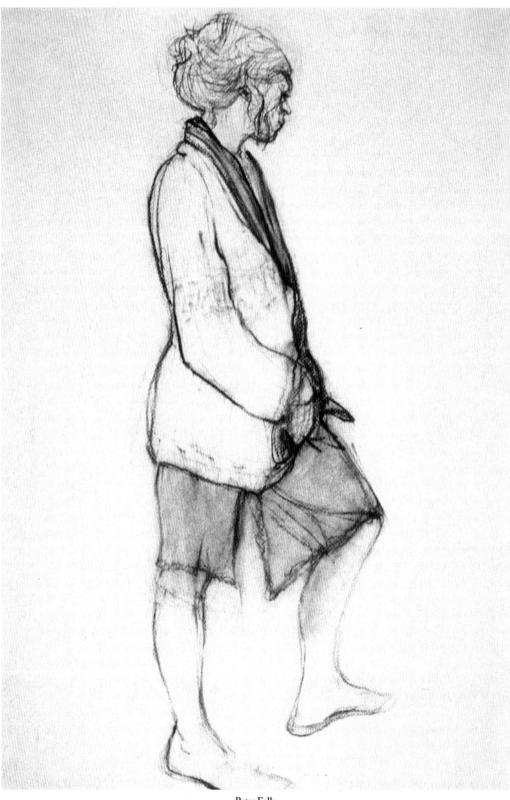

Peter Falk
GIRL IN SWEATER
Graphite pencil on paper, 24 × 18" (61 × 46 cm).
Collection of the artist.

COLOR

Being acquainted with the fundamentals of color terminology can be as helpful to the artist who paints with a pencil as it is to the painter who wields a brush.

Every color has three basic characteristics: hue, value, and intensity, also called *chroma*.

Hue is the name of a color; for example, red. *Value* is its gradation on a light-to-dark scale. Some colors are dark in their natural state, such as brown. Some, like yellow, are light and others, such as red, are generally a middle value. All hues can be lightened to become tints or darkened to form shades.

Intensity refers to the brightness of a color. Red mixed with white, black, green, or any other color will not be as intense as it was in its unadulterated state. The intensity of a color can increase in relation to the colors placed around it, the crispness of its edges, the relative size of the area occupied by the color, and the color of the light it is seen in.

PAINTERLY COLOR IN DRAWING

The painting technique that employs dramatic, exaggerated light and shade to model forms is known as *chiaroscuro*, which means "light-dark" in Italian. It is a technique that can be used effectively with pencil.

In a painterly approach to color, the local color of a form—that is, the intrinsic color of an object unaltered by light or shadow falling on it—is much more affected by the color of the light, shadow, and reflections bouncing from one surface to another. The intensity of colors becomes diluted by light. In the dark, it is more difficult to distinguish one hue from another. All colors are very influenced by shadow tones that mix with them.

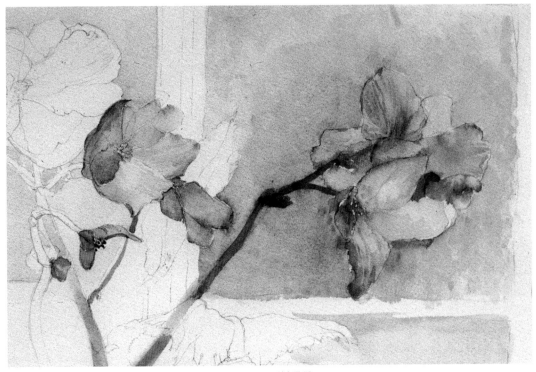

FLOWER STUDY
Graphite pencil and water-soluble pencil on paper, 20 × 24" (51 × 61 cm).
Collection of Mrs. Helen Wallerstein Meyer.

In combining graphite pencil with water-soluble pencil used as a pale wash of water, the graphite is usually applied first, as in this case, where I drew the flower and the window, then added color.

In Impressionism, color acquired a life of its own, totally detached from the objects depicted. Colors flash here and there, flickering across the surface. Separate strokes and unconnected patches and dots of color merge and become closed forms from a distance. The viewer completes the form. The outer edges, the forms of each of the components of the picture, are completely immersed in the visual totality of the image.

The idea of "reality" and beauty is changed, but the source of the cognitive information that the concept originates from is still obviously optical.

DETAIL

Of course light, or the absence of it, affects our ability to see small details. In extremely intense glare, they will be washed out; in very low light, they will be difficult to discern at first or impossible to see at all.

Generally, in a drawing approach, even tiny details are sharply defined, with each form drawn separately. Details tend to be evenly balanced throughout the image, reflecting the consistent level of light used to emphasize their sculptural quality.

In a painterly work, the intensity level of details flows with the intensity level of the light through the composition. Small objects and patterns are less distinct where contrast decreases and as light disappears into shadows and darkness. Crisp edges are easily discernible in the light, but are soft or disappear from view whenever the value inside the form is similar to the value outside it. In a painterly approach, when the eye sees a blur, the painter puts one there. A blurred edge can occur in the light, in the dark, or in the middle-gray areas of an image.

COMPOSITION

In composing a picture and arranging all of its elements, in a drawing approach, the artist's focus is primarily inside the form. The background is frequently completely omitted or just suggested, leaving large areas of the composition to the imagination.

In a painterly image, the area around the subject—the negative space— is as important as the subject itself. All of the picture must receive careful consideration because the focus is on how each shape relates to others and how light affects the way they are perceived together. Whether with pencil or brush, an artist working in a visual, painterly mode will compose areas devoid of objects with as much care as areas occupied by actual forms, paying particular attention to the way one object meets another. The edges of objects merge with the background where the shadows make them vague. They may actually become invisible, leaving the viewer to understand that although the edge is unstated, it still exists.

In a composition based on chiaroscuro, a hierarchy of points of interest can be created to guide the eye through the image. The eye tends to travel along the pathways of light and the patterns of dark and not necessarily from one form to another. It is attracted to the place where there is the most contrast. The eye is also pulled to the place where light is brightest, coming from a single source to create a center of interest. The spotlight picks out the star among the cast of supporting actors and focuses the attention of the audience there. In a composition in which light, color, edges, and details are more evenly dispersed, each actor is given a part with more detailed development and a more equally divided share of the applause.

FIGURE STUDY
Graphite pencil on paper, 11 × 8" (28 × 20 cm).

Using 2B, 4B, and 6B pencils gave me the value range I needed for developing the painterly, flowing contours of this figure and its cast shadow.

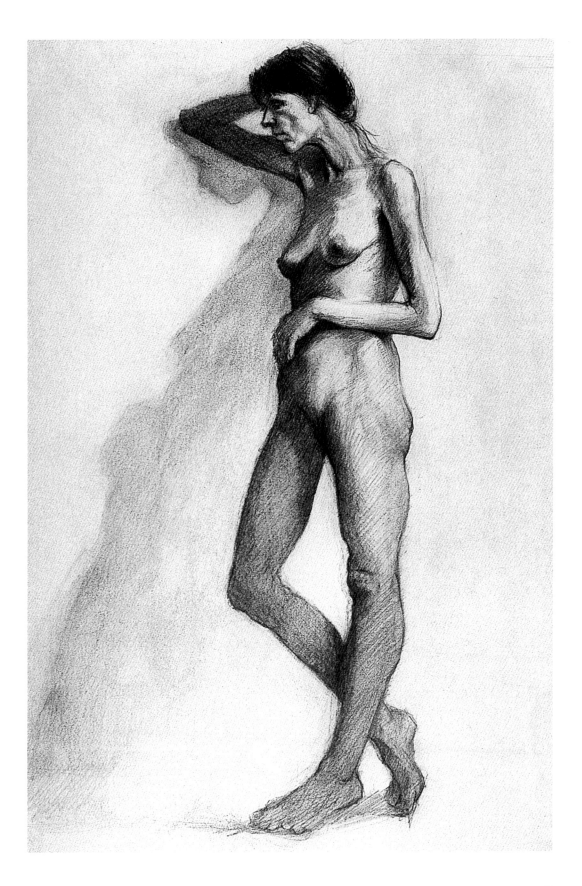

From Drawing to Painting with a Pencil

Understanding that painterly ideas can apply to both drawing and painting makes it possible to think about both in new ways. If you tour a museum and progress gradually through the galleries from the oldest works of art to the newest, you may now have a different way of thinking about what you see. There will be art born of verbal, tactile concepts next to painterly art driven by nonverbal, visual observation. Some images will fall easily into one category or another, and others will fit somewhere in between. Once you absorb the logic behind these basic concepts and the two approaches become apparent to you, it will be easier to make choices in your own work.

With an understanding of how we perceive what we see, plus a grounding in the techniques for expressing those ideas graphically, you can move easily from one medium to another, utilizing the distinctive qualities of graphic expression intrinsic to each as you develop your skills in painting with a pencil.

The chapters ahead will arm you with background information on the diverse materials available to artists working with pencil. But first, let's look at the fascinating origins of the pencil itself.

STILL LIFE!
Graphite pencil on illustration board, 17 × 21" (43 × 53 cm).

By concentrating my darkest darks and lightest lights on the skull at upper right, I establish its place as the focal point. The eye tends to enter a composition from the left and follow the flow of light to the site of greatest contrast. Tiepolo, the great eighteenth-century master of the Venetian school, used light on the edge of cloth to lead the eye around complicated compositions. Here, the edge of the paper bag serves a similar purpose.

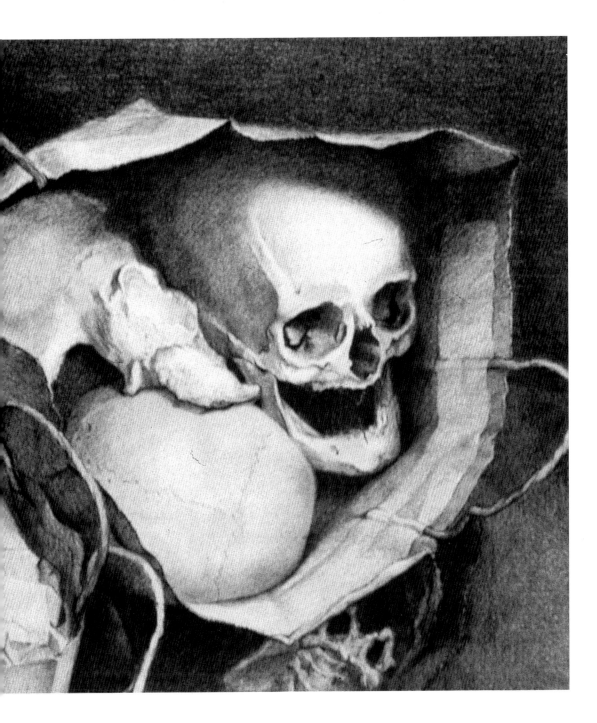

History of the Pencil

The very origin of the word *pencil,* from the Latin *penicillum,* meaning "little brush," points to the longstanding and integral relationship between the art of the pencil and the brush. Those early little brushes, invented during the Middle Ages in Rome, were made of animal hairs inserted into a hollow reed and shaped into a fine point. When it was discovered that lead could be inserted into a wood holder and sharpened to make fine lines, a new kind of "little brush," or pencil, was born.

The pencil was an extremely successful innovation. It combined the best qualities of the marking instruments that preceded it and eliminated their worst. The brush required ink, the pencil did not; the metal stylus, or silver point, required a specially prepared surface; the pencil did not. A pencil tip could be sharpened to a fine point that retained its shape and resiliency, and pencil marks were almost as permanent as those made with ink, but were much easier to change. And pencils could make marks as dark and as varied as those made with a brush, so the pencil offered some of the most important qualities of a brush.

THE "LEAD" PENCIL

A misnomer, the "lead" pencil no longer contains lead. While the Egyptians, Greeks, and Romans wrote with thin rods of lead, and Medieval and Renaissance artists and tradesmen used a lead stylus, what we refer to as a lead pencil is actually graphite. Why is it called "lead"?

According to legend, in 1565, a strong storm in a small English village uprooted a large oak tree, and under its roots chunks of what was thought to be black lead were discovered. The local farmers used those chunks to put marks on their sheep, and later, pointed pieces of the material were wrapped in string or inserted in wood holders and used as pencils. The black stuff wasn't actually lead at all, but it took more than two hundred years for the mistake to be discovered. The substance was actually a form of carbon, subsequently named *graphite,* derived from the Greek *graphein,* meaning "to write."

Later, manufacturing processes mixed graphite with varying amounts of clay to obtain different grades of hardness. The slightly porous substance was then filled with natural waxes in order to help the graphite slide smoothly across a surface and adhere to it. Interestingly, the writer Henry David Thoreau (1817–1862) had a lot to do with the development of the graphite pencil. When he graduated from Harvard, he went to work in his family's pencil business. Wanting to perfect the company's product, he imported the best clay from Bavaria. He thought that the graphite being used should be ground much finer than it had been, and his work did improve the pencil quality considerably.

Many artists include novelty and promotional pencils like these in their collection. By building your inventory and keeping pad and pencils not only at your easel or drawing table but at bedside, in tote bags, in your car glove compartment, and in other handy spots, you'll be prepared to practice your art of the pencil whenever and wherever inspiration strikes.

TODAY'S PENCILS

The renewed interest in figurative images and drawing in contemporary art has encouraged the manufacturers of art materials to experiment with adapting various media to pencil form, as well as offering innovative designs for their casings. The effects made possible by these new pencils have contributed to the blurring of the boundaries between drawing and painting. As you'll find in art stores and catalogues, there are now both "drawing" and "painting" pencils of many varieties, which we will review in the chapters ahead.

But first, let's discuss the artist's options in working with pencil at an easel versus a drawing table, and the varied positions in which the pencil is held to achieve specific artistic effects.

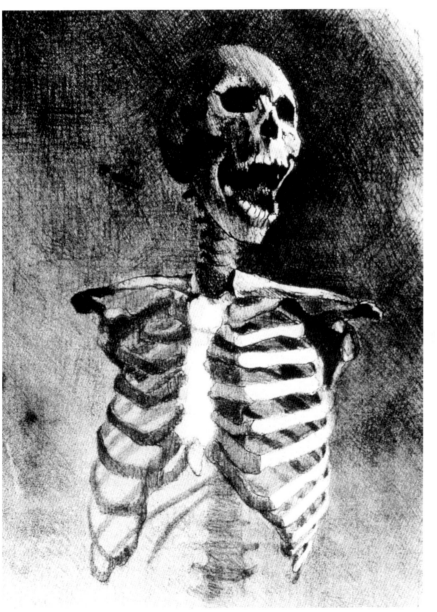

LAUGHING SKELETON
Graphite pencil on paper, 24 × 18"
(61 × 46 cm).

Note the areas of this drawing where pencil is *not* used, where I allowed the pure white of paper to play its important role in providing a strong value contrast.

Drawing at an Easel

Whenever possible, I suggest that you work standing at an easel so that you can step back to see the whole composition to judge its proportions and values correctly. In order to reach your work and still see a reasonable area of it, your arm will usually be stretched out in front of you as you handle your pencil.

We each have our own unique handwriting and individual ways of making marks, and there is no one "right" way to hold the tool with which we make those marks. The pencil itself is technically capable of an infinite variety of effects; some are more easily achieved when you draw at an easel.

ADAM
Graphite pencil on paper,
$40^1/_2 \times 19^1/_2$" (102 × 49 cm).

I used seven different grades of pencils for this figure study, ranging from the hardest, 2H, to the soft series, 2B through 9B, and worked on printing paper with a very durable surface. The large scale of this drawing and my careful rendering of musculature and other anatomical detail required many hours of very concentrated time at my easel.

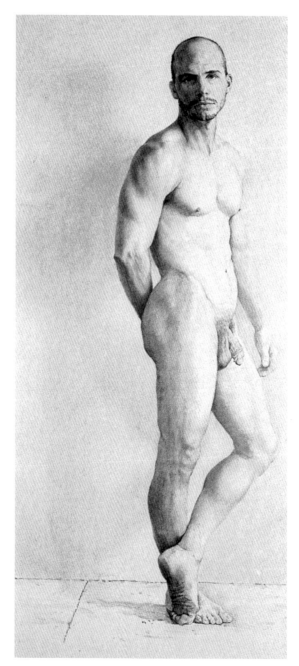

Pencil Positions at an Easel

When you stand instead of sit while drawing, you use different sets of muscles and your relationship to the surface you work on is also altered, depending on the grip you use on your pencil. Here are six specific ways to experiment with drawing in a standing position.

HOLDING A PENCIL LIKE A BRUSH

To make a long free line over a large area, your whole arm needs to move as one piece. The point of your pencil becomes the tip of a pendulum that swings in a straight line from your shoulder. The fingers of your hand can be grabbing the pencil as if you were writing; as long as the wrist and the elbow are extended, your arm will have control over the movement of the point as it sweeps across the surface. The scope of the line is only limited to the length of your arm and the size of your working surface.

If you grab the pencil in a normal writing position, your fourth and fifth fingers will automatically tuck themselves into the palm of your hand to get out of the way. When working on an image standing at an easel, after a while, your third finger is likely join the fourth and the fifth. Your grip will probably slide away from the point so that the back of your hand will not obscure the view of the marks you are trying to create. You will soon find yourself very naturally holding your pencil like a brush, with thumb and index finger only.

HOLDING A PENCIL IN A WRITING POSITION

When working small or concentrating on the details of a large drawing, there is much less surface to cover and much more need for precision. In this situation, it is useful to hold the pencil is as if you were going to write with it.

In a writing position, the pencil is held near its tip between the thumb and the index finger with the pencil's weight resting on the third finger—the fourth and fifth curled under. The downward movement of the point is controlled by the pressure applied by the index finger; the movement across the page is controlled by the thumb. The base of your hand resting on the surface helps steady it but also limits the area in which your fingers can reach to make marks. Your whole hand must be lifted to move to another location.

Using a writing position will allow you to make delicate changes in pressure on the pencil point, giving incredible control over the values and the edges of the marks that you produce.

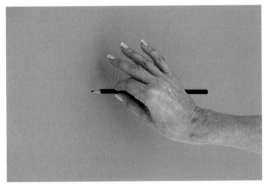

Holding a pencil like a brush, with thumb and index finger only, facilitates free and loose movement of the arm when drawing at an easel.

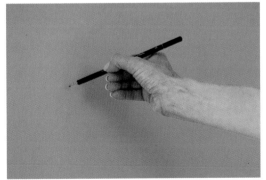

Holding a pencil in a writing position gives the hand excellent control when working on small or very precise details in a drawing.

USING A "FENCING FOIL" PENCIL HOLD

In this position, your wrist is extended as if your hand were holding chalk to write on a blackboard. Andrew Wyeth described his pencil as a "fencer's foil" in the brochure for his 1987 "The Helga Pictures" exhibition at the National Gallery of Art.

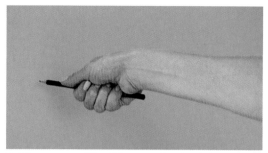

Holding your pencil as if it were a fencing foil allows you to guide the point lightly across the surface to make long, decisive, straight strokes.

HOLDING A PENCIL "EGYPTIAN-STYLE"

The ancient Egyptian method of holding a pencil-brush was with the palm up, the tool resting on the index finger, secured by the other fingers and the thumb. The pencil tail rests on the heel of the upturned palm. This position is useful when you want to make delicate curving lines. The pencil can be twisted and turned by varying the pressure of the thumb against the second finger.

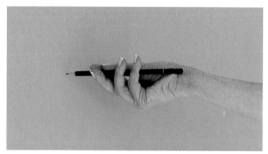

Holding a pencil the way ancient Egyptian artists worked with their tools, with the palm upturned, is a good position for making graceful curving lines.

HOLDING THE TAIL OF A PENCIL

When the very end of a pencil is grasped between the thumb and index finger, the pencil can be lightly guided across the surface. This hold might be used for a drawing such as the one on the facing page, where I employed a contour-drawing technique. My pencil was never lifted from my paper. It made one continuous, unbroken line.

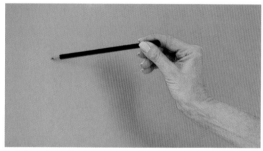

Holding the tail of a pencil in a loose grip is a good position to use when creating contour drawings (see *Another World, No. 3,* page 37).

USING AN UNDERHAND HOLD

In an underhand hold, the tail of your pencil passes under your palm. The point of your pencil is balanced between your thumb and index finger only, or your other fingers can rest along the side of the pencil for added support. Sometimes the index finger is stretched straighter on the top of the pencil for added weight, pressure, and control.

With the wrist straight and the arm extended, working with an underhand grip is quite comfortable at an easel. The pencil point is held perpendicular to the surface, which allows you to grasp the pencil near its point, middle, or at the end of its tail.

With the wrist arched gently, the underhand hold tilts the pencil at an angle, making it easy to use the side of the point for wide lines or for shading strokes.

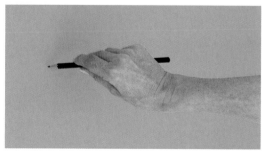

Holding a pencil in an underhand grip allows you to use the side of the point for drawing wide lines and for building shading.

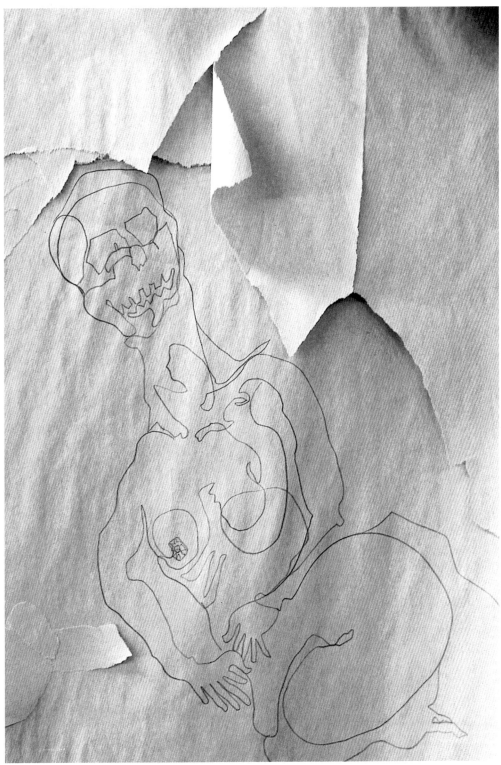

ANOTHER WORLD, NO. 3
Graphite pencil on layered newsprint, 24 × 18" (61 × 46 cm).

Contour drawing—a continuous line made without ever raising the pencil—is a good way to practice using a pencil freely and lightly. I layered and tore the paper to express many levels of emotion pulled apart in conflicting directions. The physical state of the paper is thereby used to convey and reinforce the psychological content of the image.

Drawing at a Table

For creating drawings other than those of very large scale, which are best executed standing at an easel, I recommend that you sit at a table when working—preferably at a drawing table that can be adjusted to the height and slant you find most comfortable.

Art catalogues usually show a few different sizes and styles of drawing tables from which to choose.

But if you don't have your own studio or separate space in which to keep a drawing table set up at all times, you can certainly use the kitchen table, desk, or any sitting-height surface on which to work, augmented by a drawing board, which is discussed further in the "Supplemental Materials" chapter (page 99). If you slant the board, be careful that it doesn't distort your perspective.

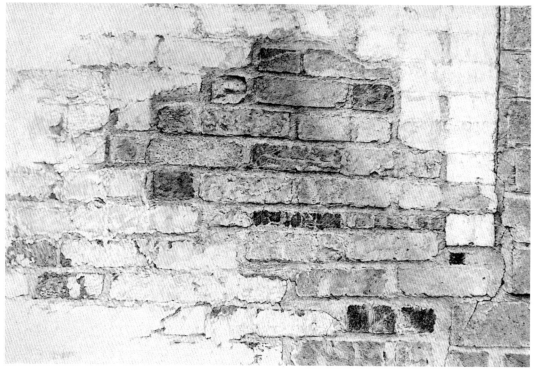

THE BRICK WALL
Graphite pencil on illustration board, 24 × 28" (61 × 71 cm).

Even bricks can have personality. I tried to depict the individuality of each one in this wall, which combines old, hand-crafted bricks with the modern, machine-made variety; some that were once white-washed, others that are starting to crumble. There are faces and figures hidden in the details of the brick and mortar, adding secret meaning to the image.

Pencil Positions at a Table

The credo "Don't hold a drawing pencil the way you hold a writing pencil" is misleading at best. It makes more sense to say, "Hold a pencil the way it will help you to make the kind of strokes you need."

Of the many possible ways to hold your pencil when drawing in a seated position, the following are among my favorites.

USING THE LITTLE FINGER AS ANCHOR
When the tip of your little finger is in contact with your working surface, it acts like the point of a compass. There is still enough contact to steady the hand but much more mobility and breadth of line are made possible. The slant of the pencil point can be subtly adjusted to vary the width of the line. The farther your fingers are from the pencil point, the freer, the lighter, and more active the marks can become. First the wrist, then the whole arm can come into play, giving your marks more spontaneity and variety of texture and tempo.

USING A PERPENDICULAR HOLD
When your pencil is held perpendicular to the paper, your thumb supports it securely against your index finger. This is a very stable position for drawing short, vertical lines such as you might use for building up a shadowy area in a drawing, as seen in the dark areas of *Still Life!* on pages 30 and 31.

As described above, this pencil hold is a useful one, but it's not very versatile, being limited to producing short vertical strokes only. Horizontal lines are difficult to create with your hand in this position.

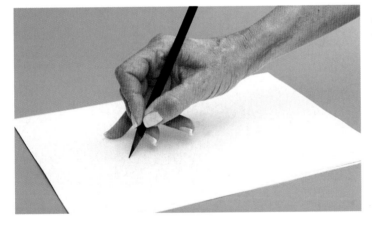

Using your little finger as an anchor when drawing in a seated position will steady your hand while allowing it a good degree of mobility.

Holding your pencil perpendicular to your working surface is a very stable position for drawing short, vertical lines.

SIGN PAINTER'S PENCIL HOLD

Sign painters secure their working hand on top of the other hand, which is curled into a fist with the little finger resting on the paper. Both hands work together. The bottom hand rocks horizontally as the upper hand makes vertical movements.

Using this grip, it's best to hold your pencil somewhat away from the point, which will give you a larger variety of longer straight strokes and curves that can be carefully controlled.

HOLDING A PENCIL LIKE A STIRRING SPOON

If you grip the end of your pencil tightly inside your closed fist, placing the pencil point straight down like a very large stirring spoon, you will be able to make bold, slashing, dark strokes.

This grip, with the wrist arched back and the point facing forward, was the way vase painters in ancient Greece held their brushes.

This "sign painter's hold" allows both hands to work together to render carefully controlled straight strokes and curves.

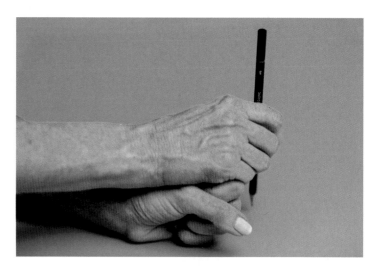

Holding a pencil like a stirring spoon enables making very emphatic dark strokes, such as those I used in shading my portrait of Milton Gould on the facing page.

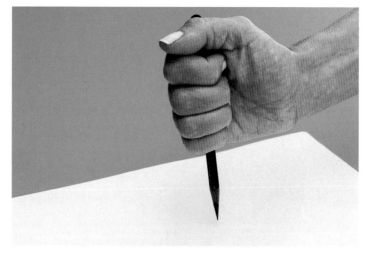

40

DOUBLE PORTRAIT OF MILTON GOULD
Graphite pencil on mylar; artist's lithograph proof, 36 × 30" (92 × 77 cm). Collection of Mr. Sheldon Camhy.

This drawing was originally made on Mylar, a translucent vellum from which a lithographic plate can be created for generating multiple prints. I left the portrait unfinished below the neck, and framed the head with dark shading around it, to focus attention squarely on Mr. Gould's lively facial expression.

CALLIGRAPHER'S PENCIL HOLD

Unfortunately, elegant calligraphy, based on variations of thickness and thinness of pen strokes, is not routinely instructed in our schools. Consequently, the relationship between the art of writing and the art of drawing, which could be connected, is quite distant in Western tradition.

In the Far East, however, the person who has mastered the difficult technique that underlies writing is automatically skilled in the techniques needed for drawing. While a brush is used for both by Chinese and Japanese calligraphers, the techniques they use can be easily adapted to pencil. A soft pencil held in the same way as a brush can produce some surprising and imaginative results.

Holding your pencil perpendicular to your paper, your thumb points slightly up and your fingers slant down; your fourth and fifth fingers control the direction of the pencil. With your forearm resting on the table, your wrist is free to guide movement. If you rest your elbow on the table, you can make even larger movements with your pencil.

USING A HALF PENCIL

One of the most effective approaches to dealing with the length and weight of a pencil is by cutting it in half. This smaller size increases control of the point and makes it easier to work for longer sessions with less tension. A single-edged razor blade will cut a circle into the wood and the lead inside will easily snap at that spot. Then you have two pencils for the price of one.

THE TWIG PENCIL HOLD

Some contemporary artists place their paper on the floor and attach a pencil to a long, straight twig, or actually dip the twig itself directly into powdered graphite or charcoal (those materials are discussed in the next chapter). The marks that result evidence a fascinating tension between accident and control. Some artists who like to think of their drawing tool as a literal extension of their hand go even further. They actually work with a pencil tied directly to their index finger.

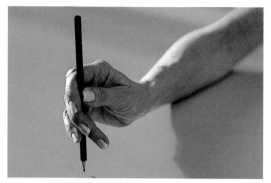

Holding a pencil in the way Japanese and Chinese calligraphers hold a brush facilitates variations of thickness and thinness of pencil strokes.

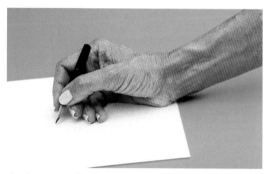

Cutting a pencil in half increases control of its point, making it more comfortable to use for long drawing sessions.

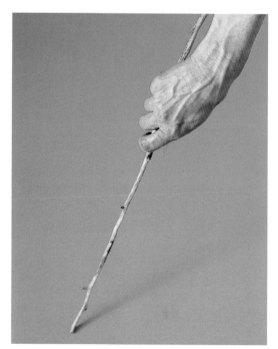

Using a long twig dipped in powdered graphite and drawing on paper placed on the floor produces an appealing mix of controlled and accidental marks.

Pencil Points

An interesting footnote to pencil history is a letter that Thomas Edison wrote to the Eagle Pencil Company, complaining that the last batch of pencils he received was too short. "They twist and stick in the pocket lining," he wrote.

Mr. Edison would not have that problem today, because a generous seven inches has since become the standard measurement of pencils produced by all manufacturers. But even at that length, a pencil's life can be extended still further with proper care. Instead of using an electric or crank-type sharpener, both of which tend to eat up pencils very quickly, use a single-edge razor blade, an emery board, or sandpaper block, which can bring a point to an even finer state without wasting a lot of the pencil. You can make your own sharpening block simply by stapling sheets of fine sandpaper to a wood block, then tearing them off as they're used up. But be aware that the way a pencil is sharpened changes the kind of marks it can make.

Many kinds of points are used in pencil painting: sharp, thin, round, flat-topped, oval-wedge, and wide-wedge.

A sharp point is generally cone-shaped with the lead gradually narrowing to a fine tip—obviously just what you need to draw fine lines. This point is best obtained by sharpening your pencil on a sandpaper block.

But the sharpest point on a wood pencil cannot equal the precision of the thinnest lead inserted into a mechanical pencil. For a thin point, the 0.03 lead will make a thinner line and stay consistently thin because it turns on the paper's surface, constantly sharpening itself.

A drawing pencil will sand itself dull. The next three are all useful blunt points.

The first is a round point, made by turning a pencil gently as you draw. This point makes soft, fat lines.

The second dull point, with a flat end, is made by holding the point perpendicular to the paper surface. A flat top is good for making an even, wide line when used at a ninety-degree angle to the surface, and a sharp, thin one when tilted to the edge of its circumference.

The third is an oval-wedge shape, made by holding your pencil firmly as you pull it over your paper or sandpaper. That point, when held normally, will make wide lines; rolled toward its edge it will make finer ones.

A wedge-shaped point is easiest to control when the pencil is a short one. At first, it seems very awkward to use a small pencil with a wedge and I remember being very frustrated with it. I wanted to throw it away in exasperation. It seemed to get in the way of what I was trying to say. Once I got used to working with it and saw what it could do, I was very glad I had not given up. It makes lovely, elegant, brushstroke lines that add a graceful, painterly calligraphy to an image.

Just as a painter has a palette of colors and a variety of brushes, the artist working with pencil needs an assortment of grades and several kinds of points prepared for work. If you take the time to sharpen a quantity of pencils before you begin, you can have a fresh one ready when you need it. Dull ones make themselves for you as you work, but it's a good idea to have some oval, flat-top, and wedge shapes ready as well.

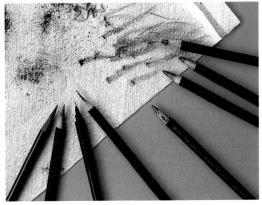

From left to right, the first four pencils have centrally located sharp points; the fifth has a flat-topped center point; the next three have various forms of wedge-shaped points.

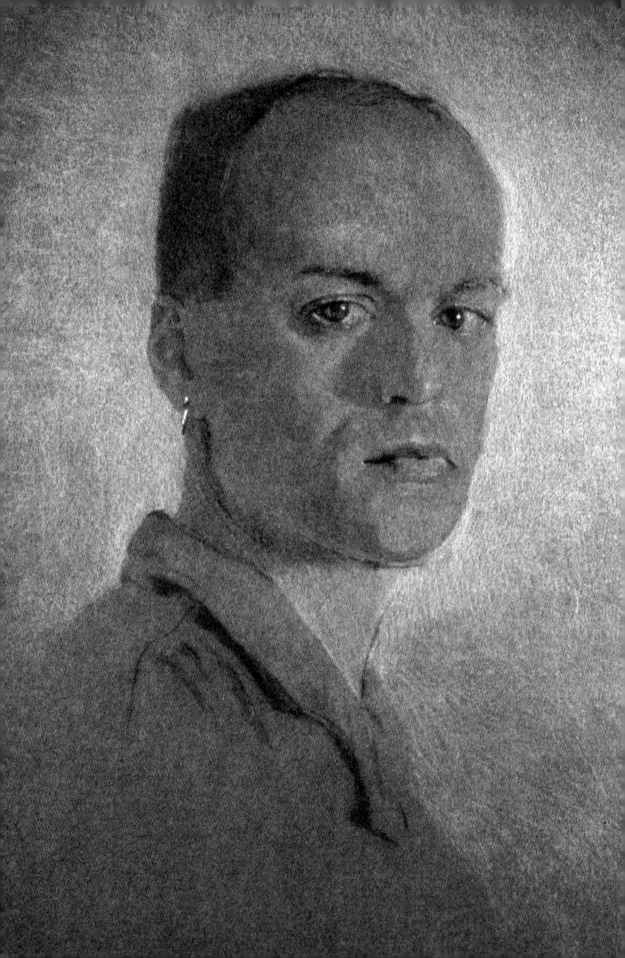

Carbon, Charcoal, and Graphite Media

Of the three categories of drawing materials—carbon, chalk, and wax-based media—this chapter deals only with carbon and its derivatives. In both dry and wet drawing media, carbon drawing tools are those that make black marks or variations of black throughout the black/gray scale.

Carbon found in crystalline form becomes diamonds. In amorphous form, three derivatives of carbon are used as artists' materials: graphite, lampblack, and charcoal.

The pages ahead present a broad spectrum of carbon products, including forms that you may never have tried before, such as vine charcoal, graphite powder, graphite sticks, and many versions of graphite pencils. I hope you'll use this information for ongoing reference in trying new materials to broaden your scope as an artist. When you reach the final chapter of this book, where demonstrations using various media are presented, you'll see that I have a strong preference for working with graphite, which I find in many ways to be the most challenging medium of all.

PORTRAIT OF MARK
Black, gray, and white pencil on black board,
20 × 15" (51 × 38 cm).

Lively texturing results by using lighter pencil over a dark ground.

Dry Drawing Media

I think you'll find it surprising to see how very many different tools are available to you for making art in variations of the black-gray scale.

So instead of reaching only for your nearest graphite pencil the next time you're inspired to create a drawing, why not experiment with a form you haven't tried before?

CARBON PENCILS

Lampblack is the material from which carbon pencils are made. Since it comes from the burning of coal, a type of carbon, the term coined for the intense black that it produces is carbon black. It is purer, more consistent, and less easily removed from the surface than charcoal.

Carbon pencils are generally available in about a dozen grades, ranging from 2H (the hardest) and H to 2B or BB to 4B and sometimes 6B (the softest). For a while, illustrators preferred to use Wolf Carbon BB with smooth newsprint paper. When the company stopped producing that grade of pencil, popular demand brought it back. Lampblack is also used as a pigment in paints and printing inks.

CHARCOAL

The residue of incompletely burned wood, bone, or vegetable matter, charcoal was probably the first drawing material used, dating back to prehistoric times. The charcoal sold in art stores today is made by heating wood in a kiln without air, the goal being to produce charcoal that will have a uniform consistency and make a dependably even black line. It comes in many forms:

Vine Charcoal

Twigs of wood, preferably willow, are used to make vine charcoal. Its quality is not always consistent. Some manufacturers mold the charcoal to give it a more uniform shape, but the real issue is how evenly it works as it is being used.

The biggest asset of vine charcoal is also its biggest liability—that it's easily removed from any surface, which is why it is often recommended for beginners. But its fragility— it tends to snap when pressure is applied to it—and the delicacy of touch required to avoid removing it by an accidental flick of the finger can make working with it extremely frustrating. However, it has its own good characteristics, and with experience, you can use it to produce beautiful, subtle tones of gray

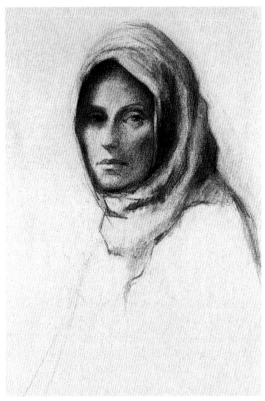

WOMAN WITH A SHAWL
Charcoal pencil and vine charcoal on newsprint,
24^1/$_2$ × 20" (62 × 51 cm).

This portrait is one of my first saved sketches, so it is quite old. Although it was done on newsprint and never sprayed, it has held up remarkably well, probably because it was framed and has spent most of its life in a closet. Newsprint darkens and crumbles with age even under the best of circumstances—so *don't* follow my example in this case. Even if you're just beginning, it's wise to use paper that you're sure will last, because you never know when your next drawing will be the very one that you'll want to treasure.

and a wonderful variety of edges of a quality unique to the medium. Its range of values and its potential for sophisticated handling make it one of the most painterly of drawing media. Daler Rowney Willow Charcoal comes in thin, medium, and extra-large sticks; Grumbacher has vine charcoal in soft, medium, and extra-hard, in square and jumbo versions.

Powdered Charcoal

Pure, unadulterated charcoal pulverized into superfine artist-quality powder is known as powdered charcoal. It can be used to transfer an image to another surface. The outlines of an original drawing are traced with a pounce wheel (similar to a pattern marker used in sewing). The powdered charcoal is pressed through the holes to transfer an impression of the original work to the new surface. After the image is transferred, it can be developed further with other forms of charcoal to produce richer, darker, softer tones, making the effects more dramatic because of the greater value range. The results are very painterly.

Compressed Charcoal

Charcoal powder is mixed with a gum binder to make compressed charcoal, which varies in hardness, depending on the amount of binder used. Some companies add linseed or similar oil to the mix, which makes it darker but more difficult to erase.

Compressed charcoal, in round and square sticks, is easier to handle than vine charcoal. Round sticks are ideal for broad strokes and to tone an entire surface; square sticks are good for making sharp-edge accents.

It tends to be a very painterly medium, producing rich, dark, velvety tones that apply and adhere smoothly to a surface; however it is more difficult to alter or erase than vine charcoal. Its depth of value is easy to achieve, but unlike vine charcoal, which can be left a delicate gray, compressed charcoal is black in color and can only be made a less dense black.

The compressed charcoal made by Conté comes in grades that increase in degrees of softness from HB, B, 2B, 3B, to 4B. Weber Costello Char-Kole offers a rich, smooth black charcoal.

Charcoal Pencils

When compressed charcoal is wrapped in paper or encased in wood, it becomes a pencil. Much cleaner to handle than the charcoal forms discussed above, the added strength and length of the pencils also makes them easier to carry, and they don't break as easily.

The paper-wrapped pencil has a string along its side that you pull to unwind the wrappping, exposing the charcoal core, which is thicker and usually stronger than the core of the wood-encased pencils.

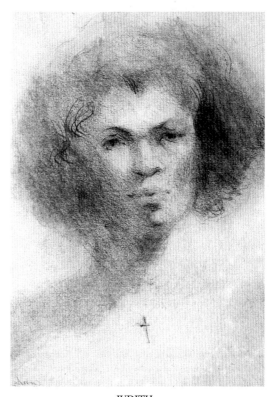

JUDITH
Vine charcoal and sanguine pencil on paper,
13 × 15½" (33 × 39 cm).

I used vine charcoal for the structural drawing of this portrait, and sanguine to add touches of warmth.

Wood-encased charcoal should be sharpened with a single-edged razor blade, then shaped on fine sandpaper into a point. These pencils are more fragile than they seem. The charcoal inside is in a thin cylinder and shatters if the pencil is dropped on a hard surface, but it's impossible to tell if that has happened until the wood is sharpened away from the core.

The charcoal pencil is the most easily controlled form of charcoal, and the thinness of its core is ideal for drawing fine lines and small, close details. Charcoal pencils are classified as hard (HB), medium (2B), soft (4B), and extra-soft (6B or 9B). Softer grades are blacker.

Charcoal is soft and giving. Line is easily changed through the slightest pressure from light to dark, from thin to thick, from a line to an area of tone. Edges are almost automatically soft unless an extra effort is made to create a crisp one. Its values range from gray to the deepest darks.

GRAPHITE

A black, lustrous form of carbon, graphite is the material most commonly found in pencils. The many different forms of graphite that follow offer artists a wide range of textures and effects. I encourage you to try them all. Our review begins with several less-known graphite forms, then moves on to the more familiar ones.

Graphite Powder

Graphite powder is ground graphite sold in pound containers at art stores such as Pearl Paint in New York. It's inexpensive, and a little goes a long way. I have been giving it to students in numerous classes for several years because I believe so strongly that working with it is an important learning experience, and my first can of the stuff is still three-quarters full. If you'd prefer to make your own, just rub a graphite pencil on fine sandpaper and collect the powder.

STEPHEN ROGERS PECK
Charcoal pencil on illustration board,
$32^1/_2 \times 26^1/_2$" (82 × 67 cm).

This large painting was developed by building the darks slowly, letting my medium-grade charcoal pencil lightly graze the textured surface of a cold-press illustration board. There is no blending.

It's impossible to predict what a person's concerns may be when sitting for a portrait. In this case, Mr. Peck—a portrait painter, an expert in art anatomy, and a teacher—was only concerned that his hair was too short, so I made it look longer.

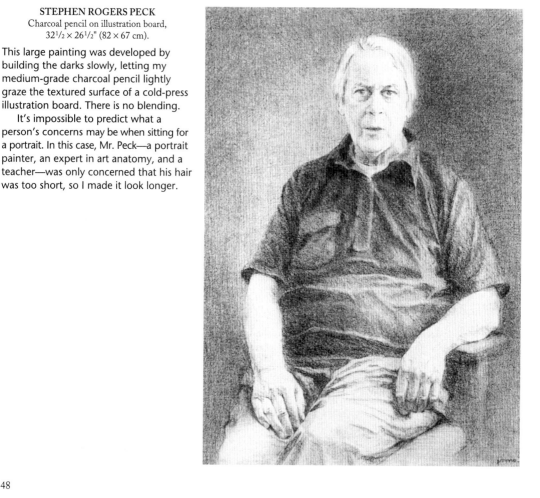

Graphite Sticks

Graphite was first found in clumps and sold in pieces as marking stones. Today, pure graphite is shaped into sticks without wood casings—a bit messy, but metal holders are available for them. Many artists prefer not to use a holder; without it, they can draw with both sides and ends of the stick.

Graphite sticks are generally available at art stores in 2B, 4B, and 6B grades. The ones made by General are square or rectangular in shape; Koh-I-Noor manufactures theirs in a rod form that can be sharpened to a point. In either form the sticks can be used to make broad, brushlike strokes or to cover large areas with tone. The width and variety of marks that can be created by breaking the sticks into convenient sizes and using their sides facilitates drawing in a very painterly style.

Graphite Crayons

Paper-wrapped graphite crayons are usually round. They are longer and thicker than graphite sticks. Soot added to the mixture of graphite and clay gives the marks they make a less shiny and blacker finish than other graphite forms. Black Graphite Lumber Crayon No. 362 is marketed by Dixon Ticonderoga.

Plastic-Coated Graphite Pencils

This pencil is a quarter-inch-round graphite stick that has been covered with a heavy resin coating. Grumbacher calls it the Pentalic Woodless Pencil, offered in HB, 2B, 4B, 6B, and 8B, ranging from the hardest to the softest. It can be sharpened to a point in an ordinary pencil sharpener or shaped into a wedge on a sandpaper block to make wide strokes of varying values, widths, and edges—just like a graphite stick, but with less mess.

Paper-Wrapped Graphite Pencils

The Eberhard Faber Company designed its American EcoWriter to look and feel like an ordinary pencil, but it's paper-wrapped; no wood is used; no tree is destroyed; no paper is wasted. This ecology-conscious company uses only recycled cardboard and newspaper for this pencil casing, yet it can be sharpened like any wood pencil, has the familiar hexagonal shape, yellow finish, and green eraser. It is sold in hard, firm, and medium grades.

The Blaisdell Lay-Out Pencil 616T is also covered in paper. It has a string unwinder similar to the one used on paper-covered charcoal pencils. Its graphite core is thicker than the core normally found in pencils.

Mechanical Graphite Pencils

Devices that hold graphite were used long before the development of modern wood pencils. They have evolved into mechanical pencils that are widely used by architects and others involved in precision drafting work.

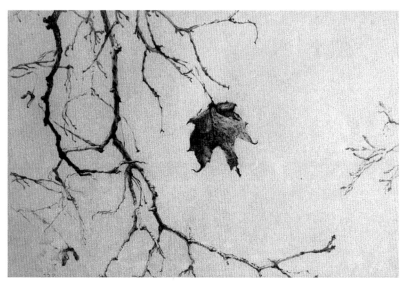

THE LAST LEAF
Drafting lead on paper,
15 × 19" (38 × 48 cm).

I used HB drafting lead on smooth sketch paper for this spare drawing, inspired by an Ezra Pound verse about leaves falling early in autumn in the wind.

Today's metal holder keeps the lead (which is, as we know, not "lead" but graphite) in place with a three- or four-part vise. A very fine sharp point can be made by spinning the rod in a sharpener called a lead pointer.

Spring-loaded and twist-feed mechanical pencils were developed in the late 1800s. The lead could be advanced a little at a time and fell out less often. The round opening that holds the lead allows it to rotate as a line is made so that the turning action of the lead against the surface keeps the point evenly worn and sharpened. The result is a line of a more consistent width. The leads are available in increasing fineness from 0.09mm, 0.07mm, 0.05mm, and 0.03mm and in a range of grades in increasing hardness from 2B to 4H. The softer leads break more easily, so some manufacturers add a polymer to the graphite to make it stronger.

WOOD-ENCASED GRAPHITE PENCILS

The wood-encased graphite pencil, commonly called a "lead" pencil, is usually what is referred to when the word *pencil* is used without an adjective to describe its contents. Softer graphite pencils usually contain a bigger core of graphite. If the cores were as thin as harder grades, they would break too easily.

Most of these pencils are made by placing the cores between two slats of wood with semicircular grooves cut in them. The two halves are then glued together to form a round, hexagonal, or occasionally rectangular shape, which is then coated with three to ten or more coats of lacquer before it is cut to size.

Wood-encased graphite pencils divide into two categories: school-grade and artist-grade.

School-Grade Graphite Pencils

The school pencil is available in a narrower range of grades, and uses its own numbering system. Its quality, uniformity, and performance are considered lower than those of professional-grade pencils. The prices certainly are lower. Generally sold in bulk packages, school pencils are inexpensive and, in fact, are often of quite good quality.

The yellow-pencil tradition began in 1850, when one Franz von Hardtmuth, while musing over what color to pick for his company's pencils, looked out his window, saw the yellow of the Prussian flag, and made his decision.

School pencils are designed for writing, but they are excellent drawing pencils. The yellow #2 (similar to a B or 2B artist's-grade pencil) is soft enough to produce dark tones easily and hard enough to keep its point for a long time. It comes with an eraser handily attached, but it's wise to test it on a separate piece of paper to make sure it does its job without smearing or leaving a pink mark on your drawing.

LYNDA HACKET'S BELKNAP'S BALLERINA
Graphite pencil on paper, 18 × 24" (46 × 61 cm).

Nina, as she is known to her friends, was drawn with a medium Mongol school pencil on bisque-toned smooth printing paper. Although the ubiquitous yellow pencil isn't usually thought of as an artist's tool, I find it to be an excellent one.

School-grade pencils made by Dixon Ticonderoga, Eagle, Utrecht, Berol Mirado, and Faber are widely available in all kinds of stores in addition to art suppliers.

Artist-Grade Graphite Pencils

In professional pencils, the harder the consistency, the higher the number that precedes the *H* designation: 9H is the hardest available. The softer the consistency, the higher the number that precedes the *B* code: 9B is the softest made. In the middle range are the *F* and *HB* designations.

Many excellent companies make artist-grade graphite. Some of them have a venerable place in the history of the development of the pencil. Pencils of superlative quality are available from all over the world: Koh-I-Noor from Czechoslovakia; Conté-Castell, France; A. W. Faber and J. S. Staedtler, Germany; Caran D'Ache, Switzerland; Derwent, Great Britain; Berol, United States; and Adel, Turkey.

Although professional-grade pencils maintain a consistent system of numbering no matter where they are made, the contents and quality of the pencils differ subtly according to each company's special formula, and some brands come in more grades than others. Derwent pencils are made in the widest range possible—from the softest, 9B, to the hardest, 9H. Currently, the 9B is made only by Derwent.

LOOKING BACK
Graphite pencil on paper,
$21^{1}/_{2} \times 19^{1}/_{2}$" ($56 \times 50$ cm).

Instead of focusing this young model's eyes directly at the viewer, I had her look off to the side, which seemed to fit perfectly with her impish expression. For the varied tonalities of her fair hair, I used a broad range of graphite, reserving my hardest pencils for the shiniest silvery highlights.

Another group of artists' pencils is designed mainly for drafting. These range from B to 10H, and are used in drafting because of the light, precise line they produce and their ability to hold a very sharp point. They are also referred to as technical or graphic pencils and are sometimes sold in sets.

Carpenter's Pencils

These wood-encased graphite pencils are square or rectangular in shape. They produce broad strokes and are particularly good for sketching or drawing wide, even lines. Made by the Rembrandt Company, they come in grades 2B, 4B, and 6B.

If you tie three Venus pencils together with a rubber band, you can make very uniform multiple lines. The pencils' hexagonal shape helps to keep them locked against one another.

These swirls were made by banding together 2H, 2B, and 6B pencils. When this technique is used for shading or for background toning, it lends graceful movement to a drawing.

TREE STUDY
Graphite pencil on paper, 18 × 13" (46 × 33 cm).

Fascinating subject matter is to be found everywhere in nature. Here, by closing in on just one small section of a tree, I emphasize the marvelous pattern and textures that inspired me to focus on the bark alone. The art of the pencil is uniquely suited to capturing such rich detail.

Textures, cross-hatching, and areas of action lines or tone can easily and rapidly be built using straight strokes of several pencils banded together.

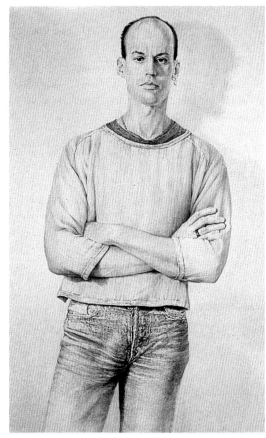

MARK
Graphite pencil on paper, 54½ × 40½" (138 × 103 cm).

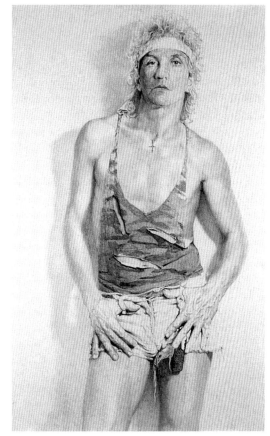

BEAU
Graphite pencil on paper, 54½ × 40½" (138 × 103 cm).

Mark and Beau are friends. My drawings of them are the same large size and are meant to be hung together. I worked on a smooth printing paper that I use often, which I acquired in a bulk, wholesale purchase made together with several other artists. Paper with a similar finish that you can find in art supply stores is made by Rives and by Arches. I used Derwent's HB, 3H, 4H, and 5H graphite pencils with darker accents of 2B for this portrait, choosing the hard grades to emphasize Beau's ephemeral quality. The edges of his form are clearly separated from the white of the paper, although they vary in hardness, softness, and value. The shadow Beau casts is his only link to the surface of the page.

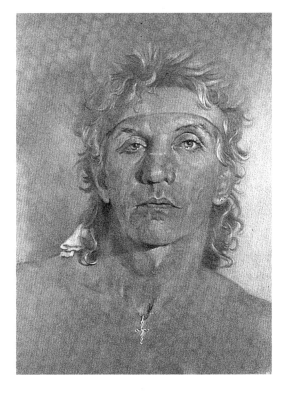

BEAU NOIR
Graphite pencil on paper, 24 × 20" (61 × 51 cm).

This portrayal of Beau's head, taken from my full-figure drawing of him above, was done in a compressed range of dark values of blacks and grays on very dark gray paper. This was an experiment to see if looking at an image this dark would cause viewers' pupils to expand, allowing them to see more of its subtle details as they continued to stare at it.

GRAPHITE FOR NONPAPER SURFACES

All of the graphite media we've reviewed so far, as well as the carbon and charcoal presented earlier, are compatible with paper surfaces of various kinds. However, Mylar, Dendril, and drafting film are relatively new polyester surfaces with which many professional artists are now experimenting. Some require special graphite pencils that will work on their surfaces.

Mylar and Dendril are translucent vellums that can be used to create lithographic or etching plates from drawings made on them. Then, editions of lithographs or etchings can be pulled from the plates. Formulas have been developed for graphite pencils that can be used on these surfaces—they are rich in value and smooth in texture—but I have used an ordinary graphite pencil successfully on Mylar (see *Morning*, opposite, top).

Should you want to explore pencils made for nonpaper surfaces, three examples are the Berol Filmograph E series designed to be used on drafting film; and the Spectra Color Design 1406 and Prismacolor 935, both of which produce very black lines on Dendril.

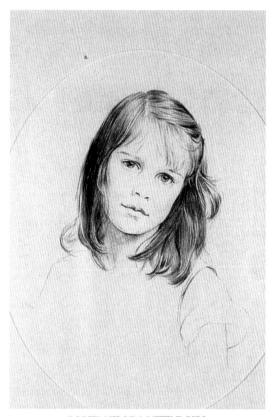

PORTRAIT OF A LITTLE GIRL
Lithograph, 20^1/$_2$ × 16^1/$_2$" (52 × 42 cm).
Collection of Atlantic Levenson International, Inc.

My original graphite drawing on Mylar was transferred to a printing plate to create this lithograph. Drawing children presents special challenges (getting them to sit still) and opportunities (beautifully expressive faces). While I always prefer and recommend working from nature, when drawing children, it's sometimes practical to have photographic reference available if more than one short sitting is required.

PORTRAIT
Printing plate,
16^1/$_2$ × 20^1/$_2$" (42 × 52 cm).

Playing patterns against each other can animate a drawing. While this background design is less pronounced than the model's turban pattern, the two are complementary. Placing the model's head slightly off-center lends added movement.

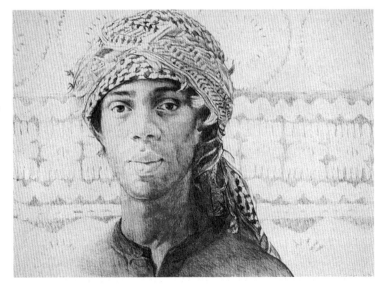

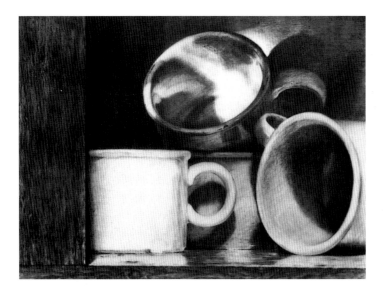

MORNING
Graphite pencil on mylar,
15 × 17" (38 × 43 cm).

As I intended to transfer this drawing to a lithographic plate, I created it on Mylar, a translucent vellum that I placed on a light box to help estimate the way the picture's values would look when I made prints from the plate. Although there are pencils designed just for this purpose, I used a standard Derwent 2B drawing pencil, which was fine for the job.

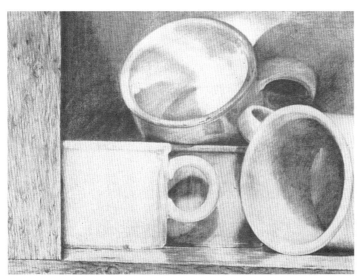

MORNING
Printing plate,
15 × 17" (38 × 43 cm).

For this version, the above drawing was transferred to this light-sensitive, positive lithographic plate through a photographic process. The printing plate turned such a lovely color from the chemical processing that I framed it and often show it as a work of art in itself.

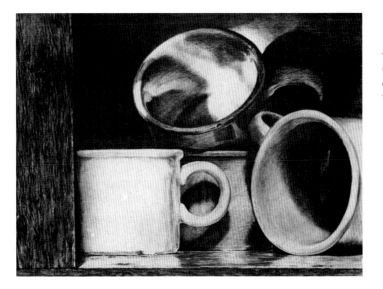

MORNING
Lithograph,
15 × 17" (38 × 43 cm).

This is the first impression, called the artist's proof, of a limited edition of lithographs pulled from the plate shown above.

Wet Drawing Media

Water-soluble media work like any other pencils when they are dry. When they are used with water, the particles form a wash that works like watercolor or ink. The pencil can be dipped directly into water and used to produce a brushlike line. When the pencil is used on damp paper, lines have soft edges and mellow tones. On dry paper, lines can be softened with a wet brush and tones darkened or lightened for an extremely painterly look.

WATER-SOLUBLE GRAPHITE PENCILS

Water soluble graphite comes in three grades: Light-HB, Medium-4B, and Dark-8B. The marks of all three darken when they are wet. Even the light wash can make rich tones. Derwent, Berol, and Koh-I-Noor Hardtmuth make graphite painting pencils. Berol Karisma Watercolor Pencils contain slightly more clay than Derwent Water-Soluble Sketching

Pencils so that it is easier to become more detailed with their sharper points. Hardtmuth Aquarell Pencils are very soft and therefore tend to be the most painterly of all.

Solvents

Ordinary graphite pencils can be used with solvents such as turpentine, alcohol, or lighter fluid and transformed into "painting" pencils. The solvents break down the graphite into pigment and binder. The liquid can be used for blending or as a wash. A liquid line will be darker than a dry one.

Lighter fluid can also be used to transfer a graphite drawing or a newspaper image to another surface. In the solvent transfer process, the image is placed face down and the back is dampened, then rubbed with a printmaker's roller, a metal spatula, or a ladle. The pressure releases the graphite on to the surface under it.

These practice marks show the range of values possible when working with the pencils dry and wet and the results of attempting to erase the darkest marks.

The column at left was made using a "dark wash" 8B pencil; the middle example was done with "medium wash" 4B; and the right column with "light wash" HB.

Working with Graphite

The common assumption is that pencils are sold in sets of grades 10H (hardest) through 9B (softest) so that a drawing can be started with the lightest ones and finished with the darkest. It seems logical, but it doesn't work. If you start a drawing with the hardest pencil, your first lines will be quite light, but what will not be noticed until later is that the hard, sharp point of the pencil is making thin grooves in the paper. The slippery grains of graphite are also filling up the surface of the paper and coating it, making it glossy. That does give the reassuring feeling that even if the drawing is overworked, it will not get dreadfully black, because no matter how hard you press on H pencils, they stay light gray.

But the problem becomes apparent as darker and softer B pencils are introduced. As they move over the surface, they reveal thin, deep, white-looking scratches that were made by the hard pencils. The darker Bs seem to slide over the slick surface of gray without being able to stick to it. There is an awkward jump in values because there doesn't seem to be a graceful way to move from shiny, silver gray to rich, velvety black.

The solution lies in making a switch in your approach to choosing pencils. Each grade of graphite has its own particular characteristics and should be used based on those. Some can be grouped together by family traits, divided into four groups: 9H to 5H; 4H to 2H; H, F, HB; and 2B to 9B.

The very hardest—9H down to 6H and perhaps 5H—are really designed to be used in drafting. Once aware of the way a hard H will gore the paper, that quality can be used in a positive way to create wonderfully crisp highlights. With a little advance planning, they can be put down sparingly first, a mark made for the light in the eye or several for the shine of the hair, to appear later when the pupil is darkened or the hair is massed in with a darker tone. The lower in the series—4H, 3H, 2H, H—can be used for modeling in the light areas.

When creating value scales, it's best to practice first with ten steps in equal little boxes, then go to a gradual progression of values merged seamlessly from dark to light.

To familiarize yourself with the range of values possible with particular numbers in the graphite series, prepare value scales—gradations from darkest to lightest tonality—for these pencils. From left, harder graphite: 9H, 7H, 5H, 3H, 2H, HB, F, B; and the softer series: HB, 2B, 4B, 6B, 9B.

The HB pencil is a good choice for laying out the beginning of the drawing. It can make dark accents and dark tones and it easily keeps lighter values in control. The F pencil is slightly harder and is particularly good for rendering crisp details.

Of the B pencils, 2B is most commonly used. The softer ones in the series aren't necessarily the ones that render the darkest tones. They are soft enough to skid over the high points of the surface, leaving the valleys white so that the area may actually seem lighter than a similar one toned with a 2B. Softer B pencils will darken areas that already have a tighter tone on them because the white will no longer be a problem. The softer consistency of the graphite needs less surface texture to help it rub off and adhere. The techniques of layering and burnishing tones are explained in the last chapter, which demonstrates their use.

The qualities of hardness, smoothness, and darkness need to be balanced against one another. Once you understand how the grades of graphite work, it's possible to use each to its best advantage or to combine them effectively. Then it will also be possible to use different forms of graphite—the side of a thick stick, the point of a sharpened pencil, or the thin diameter of a 0.03mm lead—separately or together for various desired effects.

GRAPHITE GRADATIONS

The clay that is added to graphite also changes its color. The more clay that's used, the cooler and more silvery the color becomes. The softer the pencil, the warmer and blacker its color.

The gray color in the 2H, 3H, 4H, and 5H grades is very useful for delicate shading. These will not become blacker by pressing harder, by layering, or burnishing. Conversely, no matter how gently a soft B pencil is touched to the surface, the result will be a black mark. The granules of graphite may be more dispersed and therefore appear lighter at a distance, but each one will be black.

Blackest Graphite

Graphite is usually not as black as charcoal because its surface reflects light, whereas charcoal absorbs it. Graphite is made up of flat plates that slip and slide over each other. The pressure of a drawing stroke causes them to become parallel to the surface in a flat position, which creates a slight sheen or glossy texture a little like polishing wax.

But some types of graphite pencils do produce particularly rich blacks. The ones developed for use on plastic or nonporous surfaces offer smooth, condensed, dark marks as black as ink. Eberhard Faber Design Ebony 6325, Berol China Marker 163T, Berol Filmograph OE, Blackwing, Negro, Spectra Color Design 1406, and Prismacolor 935 are a few good choices.

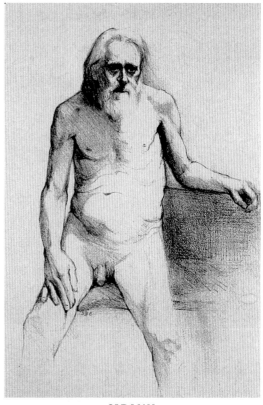

OLD MAN
Graphite pencil on paper, 15 × 13" (38 × 33 cm).

In this figure drawing, executed with an HB pencil, the lost and found edges are played against areas of tone.

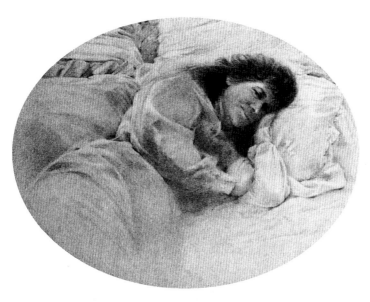

MRS. ELEANOR HELLER, RESTING
Graphite pencil on paper,
16 × 20" (41 × 51 cm).

To capture two different moods of my friend Ellie in companion portraits, I chose two very different palettes of graphite pencils. Here, with Ellie resting in the sunlight, I used only 2H, 3H, and 4H pencils to take advantage of their delicate silver color.

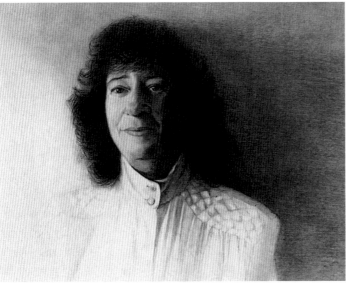

PORTRAIT OF MRS. ELEANOR HELLER
Graphite pencil on paper,
16 × 20" (41 × 51 cm).

For my second impression of Ellie in this more traditional portrait, I chose a 2H pencil for the blouse, then several softer pencils—HB and 2B through 9B—for the deeper values.

PETER, UPSIDE DOWN
Graphite pencil on paper,
20¹/₂ × 38" (52 × 97 cm).

This composition can be hung in any direction, but I've drawn Peter's eyes and shoulder, using HB, 2B, and 4B pencils, in a way that indicates he is lying on the floor. I wanted to see if a figurative image could be made to work in four directions as an abstract one sometimes can.

Paper for Carbon-Based Media

Artists' papers divide into two broad categories: smooth or rough. There are numerous varieties of both on the market, some designated for a specific medium, others that can be used with many media. The choice depends on the result you are trying to achieve.

The "tooth" of a paper is its main characteristic to consider when making your choice. *Tooth* refers to the peaks and valleys formed by the paper's fibers. Since dry pigment clings to the peaks of the paper's fibers, just how much rugged tooth you choose depends on how broken a line you want to achieve. A paper's pattern can also dominate the kind of mark that is made on it. A laid-type paper has fine lines running across its grain, which show through any massed area as a sort of plaid pattern. A wove surface is much smoother and reveals no such lines.

Small, detailed, or tight work is easier on smooth paper with hard pencils. Look for individual sheets or pads of paper that are designated *hot-pressed* or having a *plate finish* if you want a very smooth surface.

With softer media, large, broadly handled, loose work is easier to accomplish on rough paper, which comes in pads and loose sheets in a range of sizes. Particularly beautiful effects can be made by working with charcoal or graphite on handmade paper with deckled edges. Each sheet is individually formed and has a distinctive look of its own.

When working with wet graphite, there is a medium surface called cold-pressed paper, which accepts washes more graciously and evenly than hot-pressed and permits more delicate details than can be achieved on rough paper.

**STUDY OF A MODEL
IN THE STUDIO**
Graphite pencil on paper,
11 × 8" (28 × 20 cm).

I used sketch-pad paper for this study. The lighter weight of such a surface is good enough for most drawings, but as I extended my development of this figure, it became very difficult to work on because the paper wasn't strong enough to allow me to build on the dark areas without risking wearing a hole in its surface.

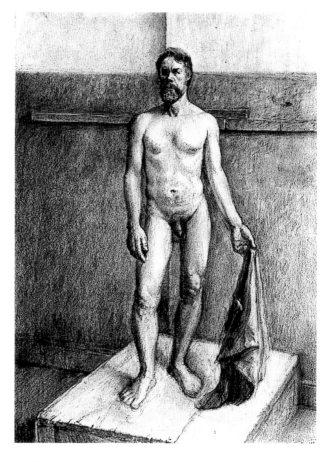

ANATOMY DRAWING
Graphite pencil on book paper,
12 × 14" (31 × 36 cm).

I appropriated a page in an old French medical book for this figure, which I drew with an HB pencil right over the book's printed line art of vital organs, giving another layer of meaning to my figural image.

TORSO
Graphite pencil on paper,
11 × 8" (28 × 20 cm).

Using an expensive, bound sketchbook, as I did here, sometimes helps to ensure that you do your best, even when working on a quick study.

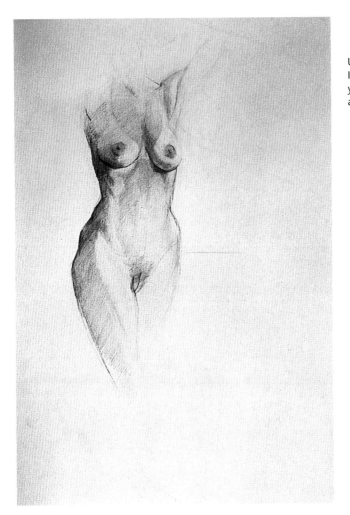

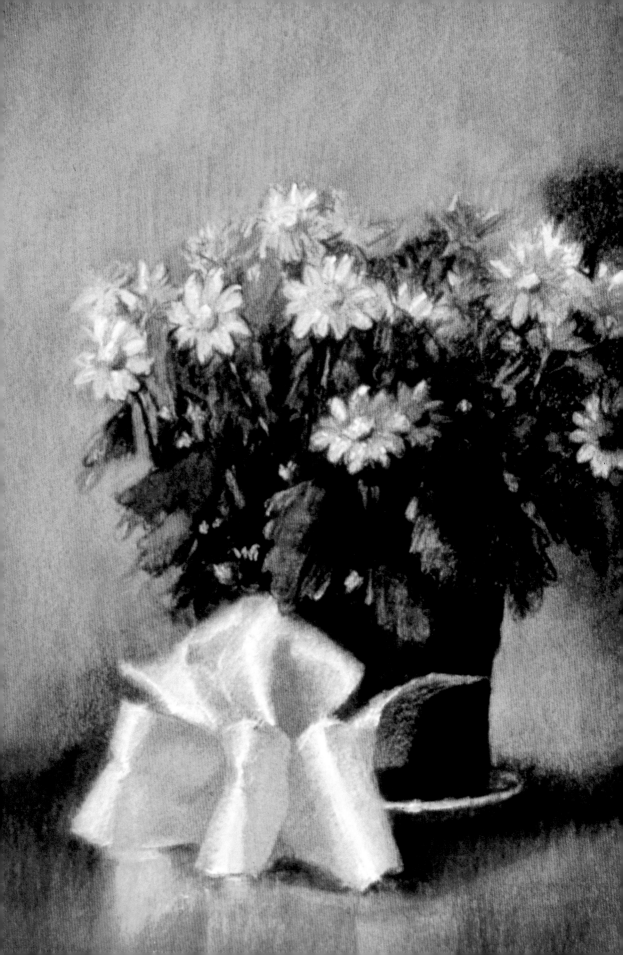

Chapter 3

Chalk-Based Pencils and Pastel Media

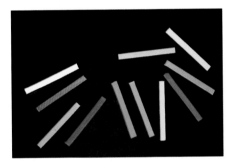

If you haven't already worked with chalk-based media, you owe it to yourself to try them.

Natural chalk is carbonate of lime, formed from deposits of tiny sea creatures that lived during the Cretaceous geological period. Their calcium content became a rocklike sediment that is usually white, light yellow, or gray. When it is found mixed with rust, it is red, or sanguine.

Chalk was used by prehistoric cave artists. Archaeologists have unearthed segments of hollow animal bone with traces of chalk pigments inside. Perhaps cave artists used them to form the first pastels, grinding the precious lumps of chalk into powder form, mixing it with water and a binder such as milk, then molding it into tubelike holes inside the bones where marrow had been.

Today, anyone who appreciates the nuances of soft, subtle tints and vivid hues will enjoy working in chalk-based media, which includes sanguine, Conté, and pastel in its various forms. This chapter delves into the background of such materials and how they are used.

YELLOW FLOWERS
Pastel and pastel pencils on paper,
36 × 24" (92 × 61 cm).

I decided that a palette limited mainly to yellow and green would heighten the brightness of this plant's blossoms, so I chose a dark-green Canson paper for its background.

Chalk Products

Just as "lead" is a misnomer for graphite, chalk is a confusing and often misused term. Nowadays, chalk is made from colored limestone. Pastels are sometimes called chalks, but very little if any chalk is used in them anymore. What are sometimes called chalk pastels are really colored chalks. They are not permanent, and come in a very limited range of colors. They are fun for blackboard and sidewalk art, but not permanent enough for serious artists. Some chalks are fired to make them harder, but they also become brittle and powdery when they are applied.

In the fifteenth century, artists began using natural red chalk for sketching and white for highlights. When used by artists today, white chalk comes in stick form for making broad strokes. A product by General called white charcoal comes in pencil form—the brightest, most opaque white of all the white pencils, and can be applied over dark areas.

SANGUINE

Derived from the Latin word for "blood red," *sanguine* connotes a red chalk with a brownish tinge that is an especially beautiful color to work with for figure and portrait studies. Because it was used by both Leonardo da Vinci and Michelangelo, sanguine evokes an old-master association and imparts a classical look when used on contemporary drawings. Many versions of sanguine are made by Conté.

CONTÉ

When French chemist Nicolas-Jacques Conté (1755–1805) placed a rod of pigment mixed with clay between two pieces of wood, he became known as the inventor of the modern drawing pencil. The French manufacturing company that bears his name has long been associated with fine materials for artists. But note that their Conté *crayon*—so named because the French word *crayon* means pencil—is not "crayon" at all, not the medium containing wax that we usually think of as a crayon.

Originally produced only in earth colors, Conté now comes in many subtle colors in both stick and pencil form. The sticks feel like super-smooth hard pastels (discussed below). Four different sanguine colors are offered and several different grades of white, black, and gray.

Conté also makes sanguine in pencil form, which is softer. Drawing with a Conté sanguine pencil on a cool-toned paper not only produces a lovely effect, but is also a good introduction to working with pastels. The brownish-red warmth of sanguine is a beautiful complement to a light gray or blue surface.

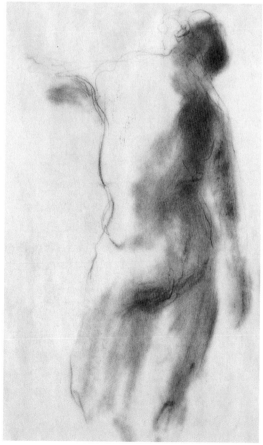

ETUDE
Sanguine pencil on newsprint, 23½ × 17½" (60 × 44 cm).

Using aged newsprint as a surface for sanguine reinforces the antique look of a sketch like this, since the brownish-red medium is so often associated with old masters' figure studies of centuries ago.

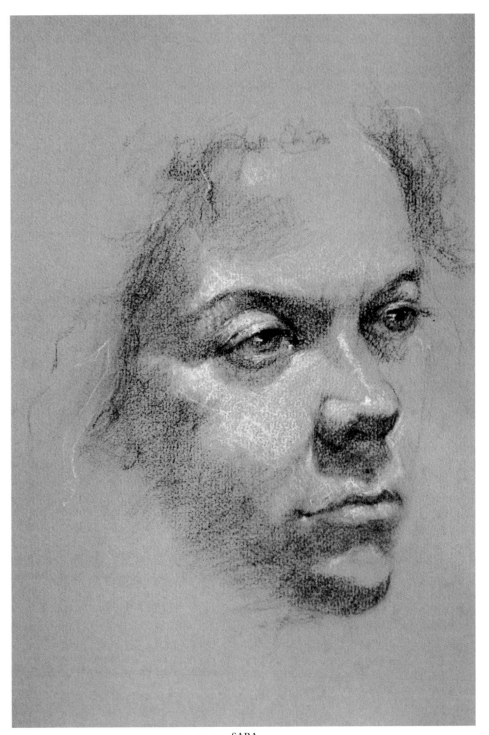

SARA
Conté pencils on paper, 21 × 12" (53 × 31 cm).

Conté pencil, which has the look and feel of hard pastel, was used in only two colors, brown and white, for this portrait. By describing Sara's hair so sparingly, just showing some strands that frame her forehead, I direct attention to her large eyes and contemplative expression.

Pastel History and Composition

Pastello, or "little paste," was created as an artist's medium in sixteenth-century Italy, then was more fully developed in eighteenth-century France into what we know as pastel. Whereas the colors were originally limited to black, white, and some earth tones, when synthetic mineral pigments were discovered, the range of colors became infinite, and artists came to appreciate the medium's charm, subtleties, and ability to portray light.

Pastels produced today are divided into four basic categories: soft pastels, hard pastels, pastel pencils, and oil pastels. The first three versions—all chalk-based—are reviewed in this chapter; oil pastel, a wax-based medium, is in the next chapter. While chalk-based pastels are generally used dry, some brands of pastel pencils have been designated to be water-soluble and achieve transparent, particularly painterly, effects when water is brushed on judiciously, as you can see in *The General Electric Plant* on page 8. When traditional pastel is wet with water, the water evaporates and leaves the pigment the same.

Pastels are made of chalk or clay and pure pigment, with gum tragacanth or methyl cellulose added as a binder. The proportion of binder determines the hardness or softness of pastel; the more binder, the harder; the less binder, the softer.

In pastel, the idea is to work from "lean to fat," from hard to soft. Pastel pencils and hard pastels are good in the beginning stages of a piece, for placing the basic composition and colors. Soft pastels are used for filling in broad areas, for building color and texture, then hard pastels or pastel pencils are useful again for details and fine-line cross-hatching work to blend and enhance larger areas of soft-pastel application.

HARD PASTELS

The most widely available brand of hard pastel is NuPastel, made by Eberhard Faber. In 96 colors, rectangular NuPastels can be carved to a point with a single-edge razor. The sticks are firm and relatively dustless. Other companies make the equivalent of a hard pastel but use a different nomenclature to describe them. Conté manufactures a set of 48 "crayons" that are clay-based and also available individually. Schwan's Carb-Othello sticks are called "colored charcoal," and come in dozens of colors.

NuPastel comes in a range of warm and cool grays. The square edges are easily sharpened into a thin point (be sure to preserve the numbered end when sharpening, to have it for future shopping reference), making this hard pastel an ideal drawing tool. Its flat sides are excellent for laying in broad strokes of color.

These soft pastels by Girault are sold as individual sticks or in brilliant boxed assortments of up to 320 colors. Since they have paper sleeves, working with them cuts down considerably on the pastelist's problem of always having messy hands.

SOFT PASTELS

Since soft pastel contains the least binder and the most pigment, it is the purest of pastel media. Pastel colors won't change with age. Pastel pigments are opaque and have a matte finish; light bounces off their surface, giving the image an airy look. The very word *pastel* as an adjective describes the light, airy tints of colors: "pastel" pink, blue, and so on. Originally, pastel pigments were mixed with a lot of chalk, which made all the colors light in value. Today, pastel manufacturers make colors of darker, richer values.

Pastel colors are mixed directly on the image, one laid over or merging with another in "scumbling" and other application methods unique to pastel work. The more individual sticks of colors you have, the easier it will be to achieve the subtle and varied effects produced by these blending methods.

Sennelier, Rembrandt, Rowney, Grumbacher, Girault, and Schmincke all offer different assortments of colors, and each brand has its own quality of softness. Sennelier's extra-soft, handmade round sticks, considered by many to be the finest pastels in the world, come in the broadest range—525 standard colors and 25 iridescent shades, and the firm also makes "giant-size" sticks in 44 standard colors. Pastels are expensive, but it's better to build a palette of fine-quality pastels purchased one stick at a time than to be tempted into buying a larger, less-expensive set of dubious quality. All of the companies mentioned above sell pastels as single sticks, so it is possible to pick and choose exactly the colors with which you want to work.

PASTEL PENCILS

Pastel pencils are pastel colors encased in wood. They are also sometimes called colored charcoal pencils because their core has the consistency of charcoal or chalk pastels. Neat and clean to work with, they can be sharpened and will hold a point.

Storing hard or soft pastels in dry rice helps to keep them clean.

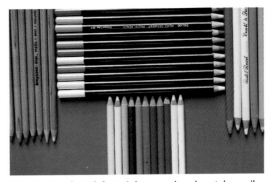

The top row from left to right are colored pastel pencils by Bruynzeel, Rexel, Derwent, and Conté; the bottom row is by Schwan Stabilo.

Pastel pencils work well alone to create an entire image or in combination with hard and soft pastels. Many artists use the pencils to lay in the initial sketch for a pastel that is then developed with NuPastel pastel and accented or resolved with soft pastel. The pencils are also often used for final detail accents and for blending two areas of color by layering pencil strokes over them.

Conté pastel pencils are made with a larger core than most of the other brands, allowing wider strokes to be made with them. They are softer, grittier, and harder to keep sharp, but they are excellent for shading. Their largest set contains 48 colors. Derwent pastel pencils are much smoother and are produced in 90 colors of the finest-quality pigments. Both companies market smaller sets and sell individual pencils as well.

Painting with Pastel Pencils

When water-soluble pastel pencils are used with standard blending techniques to create an entire image, they can be brushed with a light wash of water to achieve unusual watercolor effects. Tonal washes can be mixed with linear accents.

In addition to the brands named above, Bruynzeel makes pencils specifically identified as water-soluble: their Aquarelle brand, which comes in 45 colors.

APRIL
Pastel and pastel pencils on paper,
25 × 31" (64 × 79 cm).
Collection of Mrs. David Heller.

I worked on dark-green Canson paper and used a combination of soft pastels and pastel pencils to simulate the freshness and brightness of these crisp white blossoms and their graceful long leaves.

The Versatility of Pastel

Pastel has always been thought of as a transitional medium between drawing and painting. In fact, it is used both ways, sometimes called pastel drawing and other times called pastel painting. When pastels are used on paper in a direct linear style with most of the surface left untouched, the image is considered a drawing. When the colors are mixed together by the use of overlapping lines, scumbling (dragging one color lightly over another so that the bottom layer shows through), or blending so that the surface is more completely developed, the work is called a pastel painting. Painterly thinking can be applied to pastel pigments.

As pastel glazes the surface of paper, its pigment is left on top of the paper's fibers. It can also be rubbed into the ground with a stump or another type of blending tool (see "Supplemental Materials" chapter) to create a smooth, velvety finish.

Two notable painters who were early developers of the pastel medium were Rosalba Carriera (1675–1757) and J. B. S. Chardin (1699–1779). But it was a nineteenth-century master who took pastel to new heights of recognition, beauty, and painterly application.

THE PASTEL ART OF DEGAS

Edgar Degas (1834–1917) was painting with oils, using old absorbent paper as a palette when he noticed the matte quality that the paint acquired when oil was pulled out of the pigment by the dry paper pulp. He became fascinated by the way light shimmered back from the oil-less color. Searching for another

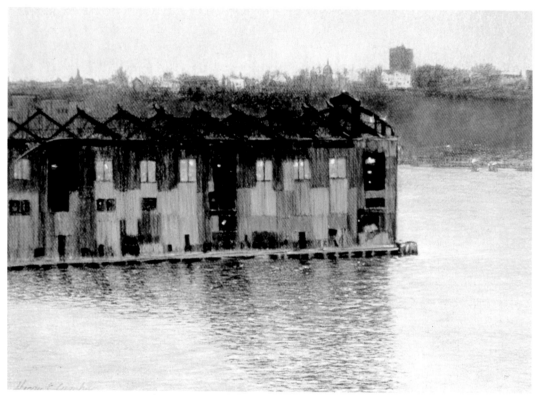

HUDSON RIVER PIER
Pastel and pastel pencils on paper, 17 × 21" (43 × 53 cm). Collection of Mr. Allan Tessler.
I used both hard and soft pastels, plus pastel pencils for detailing, to express the interaction of light, atmosphere, texture, and painterly color that I found in this river setting.

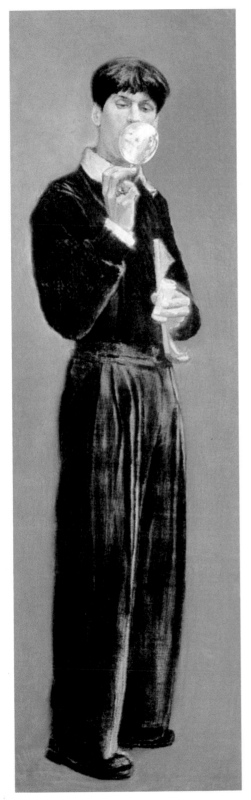

medium with that quality, he applied his painterly hand to working with pastel.

In exploring the painting possibilities of the medium, he sprayed his images with water and worked into the pigments when they were wet. He steamed the pastel sticks and applied them as impasto strokes. He used gouache, distemper, and watercolor, layering them under and over pastel, adding fixative between layers.

His style was painterly, but he built his image with linear strokes, allowing the tone of the paper to contribute to the colors he applied in broken marks, building one color over another, using pastel sticks that had the most pigment and the least filler. Imagine what he might have done with today's water-soluble pastel painting pencils!

Colleagues of Degas whose brilliant pastel work also contributed to a reawakened respect for the medium, and whose pastels can be admired on many museum walls today, are Odilon Redon (1840–1916), Mary Cassatt (1844–1926), and Toulouse-Lautrec (1864–1901). Contemporary American masters of the medium—notably Daniel Greene, Mary Beth McKenzie, and Harvey Dinnerstein—continue to expand the horizons of pastel painting.

MADRID MAN
Pastel and pastel pencils on canvas,
50 × 18" (127 × 46 cm).
Collection of Mrs. Scott Rothstein.

I chose the rough, absorbent surface of a preprimed canvas for this painting and used soft pastels by Grumbacher and the handmade Unison Colour line by Northumberland. For the face, hands, bubble, and small details I applied pastel pencils. The work is three-quarter lifesize. I did not spray it with fixative, but did frame it under glass. There has never been a problem with its safety, and its color has remained brilliant.

From Pastel Drawing to Pastel Painting

Moving from drawing to painting—and sometimes expressing both techniques in the same work—is a very natural process of development using pastels. This transition can often be seen in artists who specialize in portraiture. Several examples of my work throughout this section illustrate this point.

If you compare the black-and-white *Portrait of a Woman* and the full-color *Old Cowboy* on these two pages, it's evident how much more shading, blending, highlighting, and other painterly aspects were used for the male portrait. But also note the linear applications on that portrait, particularly on the lower half, where art of the pencil is much in evidence.

In terms of color in portraiture, there is no one "right" skin tone—both warm and cool colors are used, and one of the beauties of working with pastel is the rich nuance of color it offers in both ranges. Warm colors fall in the range of various reds and oranges; cool colors fall in the range of various grays, blues, and greens. Take advantage of that variety when describing skin. If you study the famous pastel paintings by Degas of ballet dancers, you'll find skin tones with touches of blues, greens, yellows, and oranges.

In experimenting with pastel portraits, a safe palette to start with would be cadmium red light, yellow ochre, or Naples yellow, with gray (ivory black mixed with white), Payne's gray, or cobalt blue. The warmer colors tend to be found in a band across the center of the face, on the cheeks, the lips, the tip of the nose, and the ears. Ochre is often used on the forehead. The cool colors are generally found in the jaw area, especially on men. If the paper is gray, it can be used as the cool color.

PORTRAIT OF A WOMAN
Pastel on paper, 24$\frac{1}{2}$ × 18$\frac{1}{2}$" (62 × 47 cm).

I chose gray Canson paper for this black-and-white study because of its cool, middle value, a little lighter than a gray that is halfway between white and black.

Highlights are created with dots of white on the eyes, tip of nose, and lower lip.

OLD COWBOY
Pastel and pastel pencils, 24 × 20" (61 × 51 cm).

On Canson paper of a middle gray tone, I applied soft pastels, accented with pastel pencils. In portraiture, once the relationship of features and their correct placement is established, it is easier to focus on color.

WARM BACKGROUND COLOR

Although I prefer to work from life and most of my work is done that way, it isn't always possible to do so. In this case, for my portrait of Pablo Picasso, below, my reference was a black-and-white photo. I chose an eggshell-toned surface because I had decided to use ochre as the dominant skin tone and I wanted the paper to do most of the work, serving as the middle tone of the drawing. My challenge was to cast a sympathetic aura on the image of a man who wasn't always seen as likeable. I hoped the viewer might feel some warmth for him through this portrait.

The sheet of Canson paper that I worked on has two distinct sides. One is the "right" side, which has a rougher texture designed to hold pastel pigment. Although I almost never use that side of the paper because I dislike fighting the mechanical look it automatically gives to work, I made an exception in this case, knowing that much of the surface would be left untouched so that not much of the texture would show. I wanted to use it to give a rugged feeling to Picasso's face. The hollows of the surface served to show the large, rough pores of Picasso's skin and the undergrowth of his beard.

I began my sketch with two Conté pencils: sanguine, then brown for shading. Next I used two charcoal pencils made by General: for the darkest accents, charcoal; for brightest highlights, white.

PICASSO
Conté and charcoal pencils on paper,
20 × 16" (51 × 41 cm).
Collection of Dr. and Mrs. Michael Beldock.

This portrait is based on a limited palette of warm colors on a warm surface—Mi-Teintes eggshell paper.

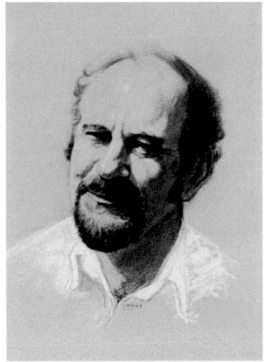

**THE RIDDLE WRITER:
PORTRAIT OF JOSEPH ROSENBLOOM**
Conté and charcoal pencils on paper,
20 × 16" (51 × 41 cm).
Collection of the Israel Museum, Jerusalem.

A slight tilt of the head lends animation to the portrait of a man whose demeanor is always full of good cheer.

When it was finished, I hated it. Something was all wrong. I didn't have the time to do another one, so I decided to put it in the car that night to be ready for my appointment early the next morning. I didn't even want to look at it anymore. It rained all night. In the morning, when I opened the car door, the drawing wasn't there. In frustration, I headed back to the house for another cup of coffee, and that's when I noticed the drawing—*under* the car, where it had fallen when I thought I had put it in the car. It had been there all night in the rain, and—it looked great! The moisture had aged the paper and softened all the edges of the drawing.

Now, I'm not suggesting that you leave your work out in the rain, but I did learn the importance of softening edges, and I have never forgotten it.

A warm-toned paper was quite appropriate for *The Riddle Writer* (on page 74), a lovely man I met in sketch class, who was compiling riddles for a book and always laughing to himself. My palette was similar to the one I used for the Picasso drawing, but with more darks and a little red added.

For *Portrait of a Young Woman*, below, I chose a darker warm Canson paper on which I could accent the lights sparkling on the model's hair. Using pastel pencils and hard pastels, I worked on the "wrong" side of the paper, which has a smoother, more even surface. The difference between the two can be seen in bright light or felt by gently rubbing both sides.

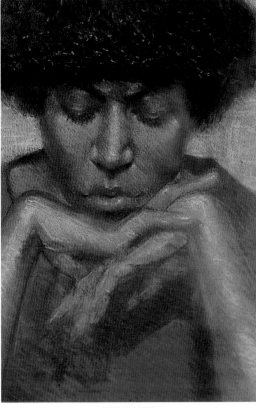

PORTRAIT
Pastel and pastel pencils on paper,
24 × 20" (61 × 51 cm).

The reflection of this model's red blouse on her warm brown complexion lights up her face. I posed her with her chin resting on her hands to take advantage of her long, graceful fingers as a design element.

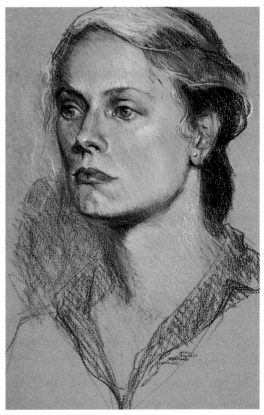

PORTRAIT OF A YOUNG WOMAN
Pastel and pastel pencils on paper,
24¹/₂ × 18¹/₂" (62 × 47 cm).

I used a combination of soft pastels, harder NuPastels, and pastel pencils on Canson warm-toned paper for this head study.

COOL BACKGROUND COLOR

When I asked my son to pose for me (see *Portrait of My Son*, page 77), I chose a cool, light-blue background to intensify, by contrast, the warm blush of his cheeks and the ochre highlight on his cheekbone. Naples yellow, light ochre, and some of the pinks and blues used in his face were added to the background in order to make the shadow tones appear darker, without having to actually darken them. I used a combination of pastel pencils and some strokes of soft pastel, including white for highlights in the eyes, on the nose, and to suggest moisture on his lips.

Related to the examples just discussed, *Portrait of Malcolm Stock* (below) shows another step toward the painterly use of pastel. Here, I employed an even fuller range of warm, cool, and ochre complexion colors, applied on a middle-gray-value Canson paper, the one most often chosen by pastel portrait artists who must work at a fast pace. Cool gray provides a base for other colors to glide over, and it blends in the gaps, softening the colors from underneath.

Both pastel pencils and a limited range of Grumbacher and Rembrandt soft pastels were used for Mr. Stock's portrait, with final touches added in pencil. Soft pastel dipped in fixative produced the impasto (thick texture) high-keyed reflections in the subject's eyeglasses.

PORTRAIT OF MALCOLM STOCK
Pastels and pastel pencils,
24½ × 18½" (62 × 47 cm).

This portrait's warm skin tones are heightened by their contrast with the paper's cool gray tone.

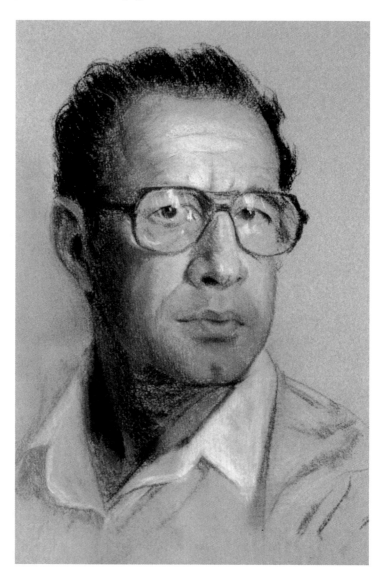

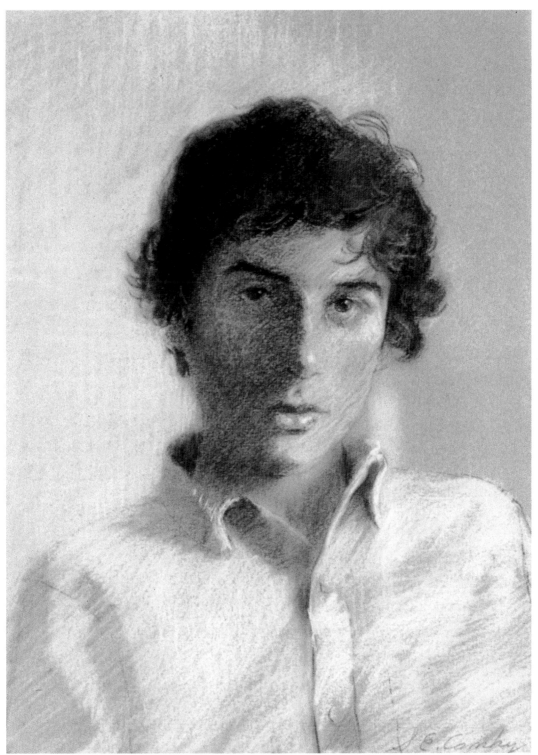

PORTRAIT OF MY SON
Pastel and pastel pencils on paper, 24 × 20" (61 × 51 cm). Collection of Mrs. George Kronen.

An interplay of opposing colors is seen here in the use of cool blue and warm yellow in the background.

Paper for Chalk-Based Media

Whenever anyone asks me which paper to use, I respond by asking, "What do you want your work to look like?" Every medium discussed in these pages will respond differently on a different surface.

Much of the information given about paper in the previous chapter, which dealt with carbon-based media, can be applied to surfaces discussed in this chapter. But the look of pastel, perhaps more than any other medium, is truly affected by the surface on which it is painted. Pastel clings to the paper's topmost ridges, emphasizing its texture, creating a lovely interplay between pigment and paper.

Instead of always starting on a white surface, try using a toned one.

Conté, sanguine, hard and soft pastels, and pastel painting pencils can all be applied to a value of gray paper or any other color. When a toned surface is used, its value and hue will glow through the color used on top, affecting the entire image and giving all the colors a harmonious underpinning.

MAGNOLIA TIME
Pastel pencils on sanded paper,
16 × 20" (41 × 51 cm).
Collection of Mrs. Susanne Stadler.

The color and texture of the support you work on is very important to the look of the finished image. For this painting made with pastel pencils, I wanted a subtle shimmer, so I prepared a sanded surface by mixing very fine white sand with an acrylic primer (Liquitex) and applying it to illustration board.

Colored Pencils and Other Waxy Media

An increased demand for new and better wax-based media has encouraged their further development in recent years. Art stores are filled with exciting variations that more and more artists are using in innovative ways for both drawing and painting.

This chapter describes the most representative and widely available versions of waxed-based media: crayons, oil pastels, oil sticks, and colored pencils. They all contain color pigments, a filler, a binder, and a natural-wax lubricant. The usual filler is talc or clay; the binder is gum tragacanth or methyl cellulose. Some are soluble in water; some in an organic solvent like turpentine.

Waxy media come in beautiful, inviting colors. The wax adds an extra-rich glow to pigments and gives them a more durable surface than chalk or pastel, although blending or erasing them is much more difficult.

Since most wax-based media can be used dry or with a solvent, it's easy to move from a dry to a wet medium and back again—establishing a concrete link between drawing and painting.

THE LITTLE MONKEY
Colored pencils on paper,
20 × 16" (51 × 41 cm).

Crayons

Like most children, I was given crayons as my first drawing tools, and to this day, the familiar look of a brand-new, big yellow box of 100 Crayola crayons makes me smile.

Now there are crayons for artists who have grown up, or at least pretend that they have. In fact, professional-quality crayons have become a fine-art medium. Some containing a kaolin clay filler can be sharpened for detail drawing, and when used wet, they can create beautiful washes.

Until recently, manufacturers thought there was no serious market for crayons, so there was little concern for the permanence, or lightfastness, of the pigments used to make them. Although that is changing, if you want to preserve waxy-media work and there's no statement on the product package as to lightfastness, it's wise to do your own test to see whether the colors will last or fade. Simply apply each color to paper in an area large enough to be cut in half. Put half in direct sunlight for a month or two; keep the other half in the dark. Then compare them.

Water-Soluble Crayons
The Neocolor II series made by Caran d'Ache comes in 84 lightfast shades that are water-soluble. Sukura's Nouvel Carré Crayons come in 150 colors, including pearlescent and fluorescent hues. Semihard and sold without paper wrappings, they produce appealing watercolor effects, as do the water-soluble

Stabilotone crayons made by Schwan-Stabilo. These 60 wood-encased crayons are extra-thick and come in a package that's complete with its own sharpener.

Organic-Soluble Crayons
The Neocolor I series made by Caran d'Ache is oil-based; it works well as a "resist" in combination with the water-soluble Neocolor II crayons described above.

The 60 Art Stix color crayons by Berol are coordinated with the company's colored pencils. The 72 crayon colors made by Derwent are also matched to colored pencils known as the No. 10 Artist series, and Studio colored pencils, which are thinner and slightly harder.

USING CRAYONS
Crayons that are not water-soluble can be used in a resist technique with crayons that are water-soluble. The waxy, water-resistant colors are used first to establish areas of the image that are to remain as they are first applied. Then, water-soluble crayon washes can be brushed over the composition. They will slide over the first waxy strokes and fill in the rest of the surface with color.

Warmed on a gentle flame, on a hot plate, or with a hair dryer, Stabilotone crayons can be used impasto-style to achieve thick, encausticlike textured effects. They have so much wax in them that the finished image can be rubbed gently with a soft cloth until it glows.

Just about everyone's first drawing tool: Binney and Smith Crayola Crayons.

Binney and Smith erasable crayons can be sharpened.

Oil Pastels

Like sophisticated soft crayons, oil pastels consist of pigments dissolved in a fossil wax. Some brands have a mineral oil or a similar nondrying agent added to keep them softer longer. They blend into a durable, mellow, lustrous surface and come in many beautiful colors and a wide range of values. Unlike oil paints, which are mixed on a palette, oil pastels are mixed directly on the image as it's being created, so the more colors you have on hand, the better able you'll be to achieve a broad range of subtle blends. Oil pastels are sold in sets of various sizes and can also be purchased individually.

Buyer Beware
Despite the fact that most manufacturers use nondrying additives, oil pastels have a limited shelf life. They harden. Since it's impossible to tell how long a set has been in the store, test the softness and consistency of several sticks before you buy any.

Buyer Take Care
Heat is deadly to oil pastels. They'll melt when exposed to direct heat or very hot weather, and as the wax begins to soften, it separates from the pigment. Protect your investment by keeping your oil pastels in a cool place.

BRANDS OF OIL PASTELS
Although the Cray-Pas permanent, nontoxic 50-color line of oil pastels has been available for more than seventy years, it took the Holbein Company's recent introduction of 225 professional-quality, lightfastness-rated oil pastels to establish the validity of the medium. A National Oil Pastel Association was formed to introduce artists to the medium and to show the work that is being created with it.

Sennelier's creamy oil pastels are based on the finest pigments and oils for their 78 classic colors, 21 iridescent, and 6 fluorescent in standard-size sticks, and 96 colors in "giant" oil pastels. The brand is quite lightfast, can be thinned with turpentine, and is said to be completely compatible with all traditional oil media. Sennelier is a very responsible company and advises its customers to use oil pastels within two years of purchase while they are fresh, soft, and responsive.

Neopastels, made by Caran d'Ache in 96 light-faced shades, are dense enough to cover a dark or even a black surface with intense glowing color. They can be melted and spread with a palette knife to create thick layers that look like encaustic paint.

USING OIL PASTELS
Oil pastels are chunky and too soft to sharpen. They are not designed for fine, linear work but are meant to be applied in painterly, bold strokes and built up into opulent textures. Rich optical color mixtures can be created by imposing one color over another. Like waxy crayons, oil pastel can be warmed, melted, mixed, and applied with a palette knife.

They can also be blended with turpentine or mineral spirits, applied, and then reworked after they have dried by scratching the surface to reveal the color or the ground beneath. That technique is known as *sgraffito*.

Counterclockwise, Paintstiks, Pentel Oil Pastels, and Holbein Artists' Oil Pastels are three popular brands.

Other interesting effects are achieved by using graphite pencil to add details over an oil pastel wash, or by using oil pastels as a "resist" for other water-based color media, the technique described earlier under "Using Crayons." Fascinating, unexpected effects often occur using resist methods, and with experience, beautiful results can be predetermined.

Erasing Oil Pastel

On a properly prepared surface, changing an oil pastel image is not as difficult as it first seems.

Begin by removing as much pigment as possible by gently scraping it with a razor or knife. Then use turpentine to wash more away. At this point, add another light coat of oil pastel to the area, either the complement of the offending color or white. (Complementary colors are those directly opposite each other on the color wheel, for example: red and green; yellow and violet; blue and orange.) That application will soak up even more of the mistake when it is scraped off in turn. In a large area, some of the original mixture can be reapplied to keep the texture of the ground consistent.

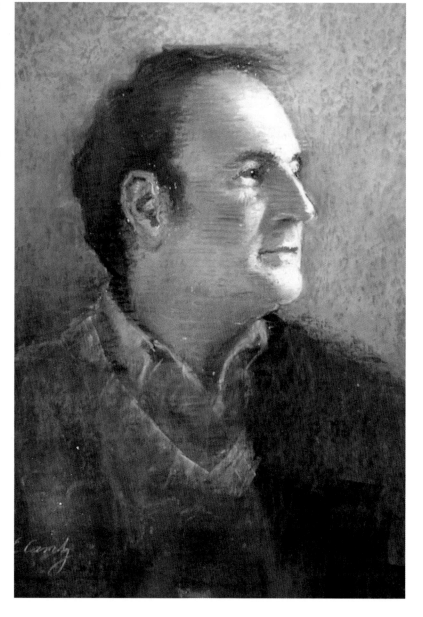

DR. HENRY WERDEGAR
Oil pastel on illustration board, 16½ × 14" (42 × 36 cm).

For the background of this portrait of my cousin, I built up layer upon layer of blues until the surface would hold no more and the waxy pigments could be pushed around to develop an airy texture. I applied a final last light glaze of red to warm the cool blues, then used horizontal strokes to pull together the mass of skin tones and give the three-quarter view of Henry's head a feeling of movement. The darks of his hair and jacket were begun with black, then glazed with the background colors to add atmosphere.

Oil Sticks

Another preferred wax-based form being used by today's artists, oil sticks are a drawing and painting medium combined, containing many oil paint ingredients made into a paste, combined with wax, then molded into a large crayon or stick format. Both graphic and painterly effects can be created with this tool.

BRANDS OF OIL STICKS

Manufacturers can't seem to agree on a generic term for oil sticks. The R&F Company calls its product Pigment Sticks. Hand-made with the finest ingredients, they are soft, color saturated, slow drying, and huge—about twice the size of most others on the market. They come in 67 standard colors, 8 iridescent, plus blending sticks in two sizes. Blending sticks contain no pigment; they are used to blend and manipulate color put down with other sticks to form transparent tints for glazing.

Winsor & Newton Oil Bars come in 35 colors in three sizes: original, slim, and stump. This excellent product contains fine pigments, linseed oil, and specially selected waxes with no driers or fillers. Oil Bars have a drying time from two to seven days.

The most widely available oil stick is marketed by Shiva under the name Artists Paintstik. The fastest drying, they dry to the touch, forming a flexible surface within a day. The sticks themselves develop a preservative coating that needs to be peeled off when you are ready to start working again, but beneath the outer skin the paint is fresh on the stick. They come in 50 colors, 12 student-grade, 16 iridescent, and 6 fluorescent. Another brand made by this company, the Markal Shiva Paintstik, is the least expensive of all oil sticks.

USING OIL STICKS

Oil sticks can be used much like oversize oil pastels. They can be dipped in turpentine for a flowing application of pigment or put on thickly with a palette knife and then manipulated to achieve textural effects. Some brands become softer and smoother when a little pressure is applied to the stick.

Crazing

Crazing is the development of tiny wrinkles caused by unequal shrinkage or drying time. Although oil sticks are reputed to be intermixable and compatible with oil paint, don't use oil sticks under oil paint unless they are applied thinly and diluted with enough turpentine so that they will be completely dry first. Also, the content of oil sticks varies from brand to brand, so test their interaction before intermixing them on your painting.

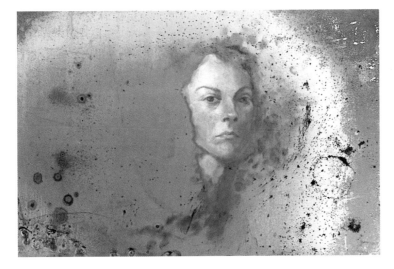

NO MORE COOKIES
Oil stick on metal,
12 × 17" (31 × 43 cm).

Metal is a very stable surface for paint, so I chose an old cookie sheet for this portrait, which includes some oil paint along with oil sticks.

Colored Pencils

Colored pencils were originally considered a medium for graphic artists and illustrators. In the 1960s, when artists such as David Hockney began to use them and major museums purchased his (and other artists') work in the medium, colored pencil gained the status of fine art.

There are standard, somewhat indelible colored pencils and erasable ones; some that dissolve in organic solvents, and others that are water-soluble. In general, water-soluble pencils dissolve more evenly and produce more brilliant colors than those that are diluted with turpentine.

BRANDS OF COLORED PENCILS

Some colored pencils are designed to be used dry only. Although they might be soluble in water or a solvent, if that isn't specifically recommended by the manufacturer, the results are quite experimental. The following brands fall in that category.

Eberhard Faber introduced colored pencils to America in the 1930s. The company's current Design Spectra line comes in 96 colors made with pigments similar to those found in quality oil paints. These lightfast, dust-free, nonhazing colors blend smoothly. Each pencil's black wood casing is tipped with the color it contains, making it easy to see which one you

want to use next. The company also makes an erasable pencil called Col-erase that comes in a range of colors.

Rembrandt's Polycolor Pencils, in dozens of colors, are blendable, lightfast, slow wearing, and resistant to water and smudges. They can be used on all kinds of surfaces, including cloth, coated papers, plastics, and wood.

Daniel Berolzheimer, the founder of Berol Pencils and a pioneer in the manufacture of colored pencils, began manufacturing 36 lightfast colors during the 1930s. Today, Berol's Prismacolor line of 120 colored pencils has 48 Art Stix colors to match. The smooth, thick, permanent pigments are water-resistant and lightfast and can be used on fabric as well as paper surfaces.

Water-Soluble Colored Pencils

Many companies produce water-soluble colored pencils with differing thicknesses and other qualities that achieve varied effects. Most can be used as conventional colored pencils, then washed over with a wet brush for flowing color effects.

Derwent offers 72 Watercolor Pencils; Staedtler Karat Aquarelle, 60; Conté Aquarelle, 48; and Bruynzeel Design Aquarelle, 45. Each of these has its own distinctive characterisitcs. Karat and Bruynzeel are the most easily soluble.

The color-coded ends of Derwent colored pencils make instant identification easy, a big plus when you're holding and working with many at the same time.

YELLOW LEAF
Colored pencils on cardboard, 30 × 24" (76 × 61 cm).

I used the cardboard back cover of a sketchbook for this impromptu drawing. Berol Prismacolor pencils come in many greens that are useful for landscapes and florals, such as the olive, grass, peacock, and apple greens seen here—and a good range of yellows, including canary, lemon, and burnt ochre.

Organic-Soluble Colored Pencils

Derwent has two lines of pencils that are soluble in turpentine or mineral spirits, and both come in 72 colors: Studio Pencils are thinner and harder than the Artist's Pencil line. They keep their point longer for tighter, more intricate work. The Artist's Pencils are soft, smooth, and easily blendable. They have the added advantage of being coordinated with stick-shaped crayons of similar colors for covering larger areas or using broader strokes. When thinned with solvent, all three varieties can be used with a brush. The Derwent Company rates the lightfastness of its pencils from 5 (excellent) to 1 (poor).

Prismacolor is made in 120 thick, soft, blendable, water-resistant colors. A third of those colors also come in the company's line of Verithin Pencils, a thin, strong lead that's ideal for rendering fine details. They can be made into color washes with turpentine or mineral spirits. The lightfastness of each color is rated from A for excellent, to E for fugitive—pigments that fade easily.

USING COLORED PENCILS

Colored pencils can be used under and over markers, with watercolor, acrylic, pastel, and egg tempera. Graphite makes an interesting final layer over colored pencil work, intensifying the values and adding sparkle to hues.

Whether the pencils are water- or organic-soluble, the same general techniques can be used if you consider colored pencils to be watercolor or oil paint in solid form. Colored pencils may be used to build color and form into a wash that is still wet or one that has been allowed to dry.

There are several ways to begin a colored-pencil work of art. You can apply an area of color dry, then glaze it with solvent. Or, the surface can be dampened and the color applied on it. Or, you can dip the point of your pencil in liquid, then draw with it. It will create a bolder, more intensely colored line. Still another way is to rub a wet brush against your pencil tip. It will pick up color that can be used to put down a stroke or a tone.

Optical Mixing

Colored pencils can be blended by a technique discussed earlier in connection with pastel: mixing colors optically. In this process, individual colors are applied next to each other, scumbled, cross-hatched, or layered in a manner that allows the eye to merge them into different hues. Although the technique is suited to any medium, colored pencils, pastels, oil pastels, and oil sticks are the most dependent on its use to create color mixtures.

Layering

Layering, or placing one thin layer of pigment over another, is the way colors, tints, and shades of colored pencils evolve. Vibrant color is developed slowly. Dark values are built gradually. Blacks alone or applied to darken shades can leave an area dull. If black is used to deepen a value, use the black as a first layer and the hue as a glaze over it.

Burnishing

In colored pencil technique, burnishing is the pressured layering of a light color over a darker one to create a paler tint or to smooth pigment into the paper. A lighter variation of the same color, its complement, or white can be used. For burnishing larger areas, candle wax can be used instead. It's generally more translucent than white colored pencil and does not produce as cloudy a glaze.

Colorless Markers

This tool, designed for blending felt-tip markers, works quite well in dissolving most colored pencils, enabling the pigment to be used like paint. A colorless marker can be applied to most paper surfaces without causing them to buckle in the way that water would. Colorless markers can also be used to intensify or lighten colors and to soften edges.

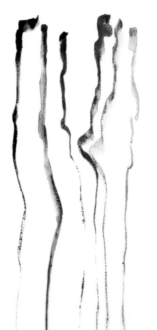

Here, water-soluble pencils have been applied thickly, then dried and brushed with water.

Before using them on a work in progress, dip water-soluble pencils in water to test the kind of line they will make when wet.

Water-soluble pencils scribbled and spread thinly with water become transparent.

Wet pencils produce lively effects when they are splattered.

Testing waxy colored media on a black surface heightens their visibility.

Surfaces for Waxy Media

Many kinds of supports work well with colored pencils and other waxy media. To review them in the sequence used for this chapter, let's begin with surfaces that are most suitable for oil-based drawings or paintings.

SURFACES FOR OIL PASTELS AND OIL STICKS

Any medium made with oil needs to be used on a surface that won't be affected by the destructive nature of oil acidity. Several companies have papers with a protective layer against oil penetration designed specifically for use with oil pastels and oil sticks. Among them are Strathmore 403 Pastel Paper and St. Armand's Sabretooth. New York Central Art Supply, a store that has been in business since 1905, makes two surfaces that are particularly receptive to oil pastel: Clay-Coat, which has a smooth finish, and Pastel Deluxe, a grittier finish designed for pastels as well as oil pastels. All of these are sold in individual sheets in a wide range of sizes.

Oil pastels and oil sticks can also be used on canvas that has been properly primed with gesso and has a rough enough texture to hold the pigment.

Two imaginative and inexpensive surfaces that produce unusual effects can be found at the hardware store: "Hardware Cloth" and a roofing material called Felt. They were recommended to me by an artist colleague, Marilyn Britvan, who uses those surfaces for both dry and oil pastel work.

Glass, mirrors, metals, ceramic, and acrylic surfaces are all promising possibilities for oil pastels and oil sticks to adhere to. *No More Cookies*, on page 85, is an example of oil stick and oil paint on a cookie sheet. Experiment, and you're apt to find many unusual effects.

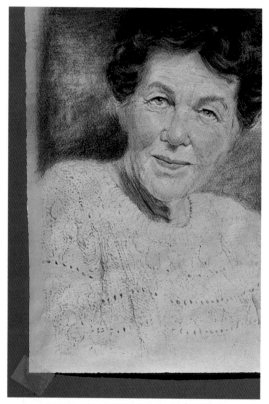

PORTRAIT OF MRS. ELEANOR GOULD
Colored pencils on mylar with red backing, 10 × 8" (25 × 20 cm).

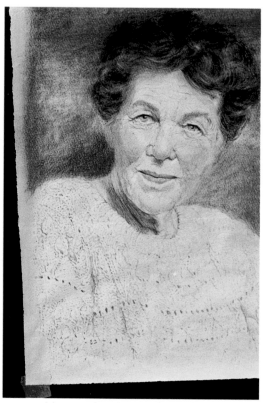

PORTRAIT OF MRS. ELEANOR GOULD
Colored pencils on mylar with white backing, 10 × 8" (25 × 20 cm).

Home-Prepared Surfaces for Oil Pastels and Oil Sticks

A surface used for oil sticks must be primed to prevent deterioration caused by the oil. Several thin coats of acrylic gesso applied with a paint roller or brush will turn any sturdy paper, illustration board, stretched canvas, or Masonite into a surface for oil pastel.

To add tooth to the ground, add sterilized fine grain sand or pumice to the gesso, mix, and apply. An industrial paint sprayer can be used to cover large areas with the ground.

Lithographer's carborundum of various grades mixed with black gesso makes a gritty, shimmering surface. The rougher the surface, the more pigment it will hold and the richer the colors and texture can be. More layers of pigment will be able to stick to the ground. The valleys can be toned with pigment diluted with turpentine.

The smoother the surface, the easier it is to wipe or scrape away oil pastel pigments, not just to correct mistakes but to create texture and translucent effects.

SURFACES FOR COLORED PENCILS

Dry colored pencils can be used on almost any paper. On smooth paper, great delicacy and detail can be achieved but less pigment is rubbed off against the surface, so there is a limited range of depth and intensity to the color. On paper with more tooth, colors have more bite. Some choices are printing papers such as Rives BFK and Arches Hot Press and illustration boards such as Strathmore and Museum Board; each has its own characteristics, and all are of excellent quality.

Mylar is also a good surface for colored pencils—an absolutely stable, permanent support. It can be used on either or both sides to give added depth to an image. Its translucence allows light to add glow to the colors. Several layers of Mylar can be put together to form an image, or a single sheet can be backed with a white or toned support for added color nuances.

Colored painting pencils require a surface that can sustain the solvents mixed with them. Use watercolor paper when applying a wash technique with water-based pencils. When using colored pencils and turpentine or mineral spirits as solvent, a primed surface is called for.

Keep in mind that the color of the ground affects the colors used over it. A black surface can intensify the colors in a very different way from a white surface. Two black surfaces for colored pencils are Arches Cover Black and Black Crescent Mat Board Smooth.

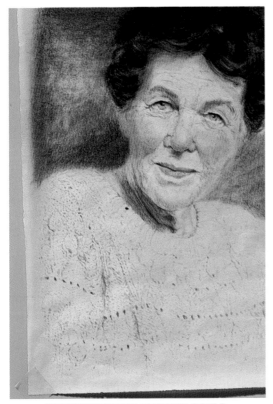

PORTRAIT OF MRS. ELEANOR GOULD
Colored pencils on Mylar with blue backing, 10 × 8" (25 × 20 cm).

Mylar is a translucent film on which I created this drawing, using colored pencils. When I place the Mylar on red paper (far left), the color and value of that surface shows through, affecting the image dramatically. For another version of the painting (center left), I place the Mylar on a white surface. Here (near left), a blue ground behind the Mylar produces yet another look.

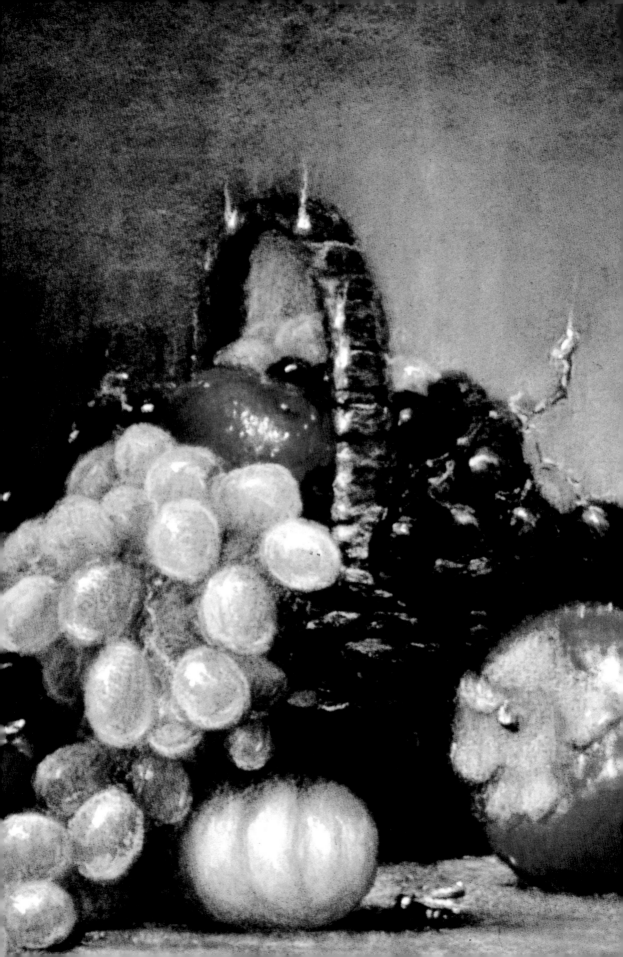

Chapter 5

Supplemental Materials

As we've seen from all the previous chapters, pencil and paper are certainly not the only materials at our disposal. Added to the various media we've reviewed, tools that aid in their use can further enhance your work. This chapter presents a range of such materials.

Since the various media discussed in these pages can be embellished by painting mediums and by fixatives, first we'll review those two categories of materials.

Erasers and blenders also play important roles in art of the pencil. A thorough rundown of those tools comes next.

Other equipment and accessories that can make your working sessions more efficient and more successful conclude this chapter. With new introductions continually reaching the market, it's always a good idea to be on the lookout for the latest items in catalogues and at art stores that may become welcome additions to your studio supplies.

STILL LIFE WITH FRUIT (DETAIL)
Pastel and pastel pencils on paper,
24 × 36" (61 × 91 cm).

As this painting evolved, I added dark grapes on both sides of the triangular arrangement to broaden its base. I included the little bug just for fun, but it also acts as a bridge between the groups of fruit resting on the table.

Solvents and Fixatives

SOLVENTS

Turpentine, lighter fluid, and Bestine Rubber Cement Thinner all work as solvents for charcoal, graphite, conté, wax crayons, and oil pastel for blending, for building areas of tone, and for painting washes.

Colorless blenders are markers that contain solvents for use with colored pencils. They blend colors, soften edges, and develop tonal washes.

Eberhard Faber Design Colorless Blender 311-F comes with a wedge-shaped nib. The EF Design 2 and Berol Prismacolor Clear Blender both have broad and fine tips.

WORKABLE FIXATIVES

A fixative is a liquid sprayed on a surface to aid the adherence of fragile dry media such as charcoal and pastel. *Workable* fixative, as opposed to *final* fixative, discussed below, allows for some erasing. It holds down the layer of the drawing under the spray and creates a new, transparent surface to work on top of. All fixatives (workable or final) alter the look of artwork, but that is often a necessary price to pay for the advantages derived.

A popular brand of workable fixative for charcoal and pastel is Krylon.

Using Workable Fixative with Charcoal

When you work with vine charcoal, a time comes when trying to put down more charcoal actually pulls some away from the surface, leaving even less there and destroying the original image without adding to it. This is when a workable fixative coating holds down what's there but allows more charcoal to be added. Several light, successive coats permit ongoing development of the drawing, which would not be possible otherwise. Some erasing can be done after each layer, but as the layers increase, it becomes harder to eliminate marks in the protected layers.

Using Workable Fixative with Hard or Soft Pastel

Pastel pigment frequently fills the fibers of paper until the surface can absorb no more. The freshness of the color becomes lost and muddy-looking. A light coating of fixative at this point produces helpful results. The spray makes light areas slightly darker and darker areas slightly lighter. With the new surface to work on, there is also room to go lighter in the lights and rebuild the structure of the dark areas, correcting proportions, placement, and redefining shapes. This procedure can be done two or three times before the texture of the work looks gritty.

Using Workable Fixative with Graphite

Workable fixative is sometimes applied over graphite as well, because some brands of pencil smudge more than others. Although I rarely find the need to use any fixative, a good choice is Grumbacher's Myston matte finish.

FINAL FIXATIVE

A final protective coat is just that; once sprayed on, it seals everything underneath, making it very difficult to change anything. Final sprays come in both matte and gloss finishes. They are obviously designed for preserving a finished piece, and are particularly recommended for fragile charcoal work.

Final fixative is often necessary for colored pencil and oil pastel images. Because of the wax in them, a "bloom" of whitish haze may develop without this added protection. But for other media such as traditional pastel or graphite pencil, I avoid chemical protection whenever possible, preferring to preserve my work by matting and framing it under glass.

Matte Finish

Protective sprays like Grumbacher Tuffilm Final Fix in matte finish will not add shine but it may give a milky, dulling look to everything, even to graphite.

Gloss Finish

Gloss finish adds a sheen to work. Although it would not seem logical to use it on media that naturally have a matte finish, such as charcoal or pastel, it works well because both are very absorbent and soak up much of the sheen.

USE ALL FIXATIVES WITH CAUTION

- Always spray your work out of doors. The fumes are highly flammable and toxic. Most fixatives are strongly scented as a warning that you are spraying dangerous chemicals into the air; odorless fixatives don't offer that built-in reminder.

- Always spray away from your work before aiming directly at it. The beginning blasts of fixative are often not even and may cause permanent spotting on your art.

- Place your work on a flat surface so that any extra spray will not roll down the image in rivulets. Hold the spray nozzle at least one foot away from your work: too close will cause flooding; too far away will result in a whitish, chalky look.

- Less is more. Thin, even, repeated coats work best. Allow each coat to dry before the next is applied.

PINK DAISIES
Pastel and pastel pencils on paper,
16 × 20" (41 × 51 cm).

Applied to dark-gray Canson paper, the pinks, whites, yellows, and greens take on added brightness.

Erasers

Obviously, erasers are used mainly to correct mistakes and to clean up smudges. But you may be surprised to learn that erasers can also be used to *create* images, as shown and discussed in the "Painting with an Eraser" demonstration in Chapter 6.

With so many erasers on the market, which should you choose? The perfect eraser would be one that wipes out all drawing media without smudging the image or damaging the paper, because disturbing surface fibers changes the way the medium goes down over it. The value of a new mark may be much darker than the original one or it may not take at all. Although such a perfect eraser does not exist, there are excellent ones that serve different purposes. But before using any eraser, try the gentlest method first. Just blowing on charcoal or pastel might remove enough surface particles to lighten a drawing so that corrections can be made—or just snapping your finger on the paper may do the trick. A soft painting brush can also be enlisted to remove dry pigment.

KNEADED ERASER

For carbon, charcoal, graphite, pastel, and crayon, a kneaded eraser is one of the gentlest, most effective, all-purpose erasers made, pliable enough to be molded into any shape, and it doesn't leave eraser dust behind. Pulling it like taffy helps increase its absorption and in effect cleans its exterior surface.

By flattening out a kneaded eraser, placing it firmly over an area, and then pulling quickly, pigment will be lifted away without rubbing the paper surface. If you must rub, a kneaded eraser's softness makes it nonabrasive.

The Eberhard Faber Design Kneaded Rubber is sold in small, medium, large, and extra-large. It comes wrapped in clear plastic and should be stored that way when not used for a while; otherwise, it may dry out.

GUM ERASER

Use a gum eraser (also called a soap eraser) primarily to clean up large areas when finishing a pencil drawing. A good choice is Artgum, made by Eberhard Faber Design.

Gum erasers are made of a rubberlike material that has a cleaning agent in it. Not designed for soft media like charcoal or pastel, which it would smear, gum erasers should be tested before being used on any colored surface, because sometimes the cleaning agent will alter or remove the paper color along with the medium used on it.

RUBBER ERASER

Use rubber erasers (most often they're pink) for work executed in pencil, but test them first, because some leave a pink stain on paper—especially those found on the ends of most school-grade pencils. Pink erasers also come in arrowhead-shaped rubber tips that fit over the end of any pencil, and in rectangular wedges.

Since no single eraser is perfect for all erasing functions, I recommend that you keep an assortment on hand.

Erasers can be sharpened with single-edged razor blades or on sandpaper.

All are much more abrasive than kneaded or gum erasers. But because they are also much harder, they can be shaped with a razor blade and used to cut a thin, crisp, white accent line into a massed area.

I recommend the Eberhard Faber Pink Pearl for erasing pencil. The EF 400-A pink eraser comes in a pencil-like form which fits into a cylindrical holder.

SOFT VINYL ERASER

Soft vinyl erasers were originally designed for removing graphite from mylar, polyester film, and fragile surfaces. When used to erase graphite from those or ordinary paper, vinyl erasers are less abrasive than rubber. Some popular brands are Staedtler Mars Plastic, Magic-Rub Plastic, and Koh-I-Noor Drafting Film Erasers. All need to be cleaned often in order to prevent smudging. But when they're dirty, they make excellent blending tools, leaving painterly marks in their wake. Vinyl erasers also come in cylindrical sticks that can be razor-shaved to a sharp point for detail touches.

ALTERNATIVE ERASING TOOLS

Instead of using an eraser, absorbent material such as a cotton swap, a piece of an old T-shirt, a tissue, or extra-soft toilet paper, can be lightly dabbed at a problem spot to pick up carbon, charcoal, pastel, and even graphite without smearing it, if you are careful.

Another choice is chamois (pronounced *shammy*) a soft cloth sold in art stores. It is expensive, removes lots of pigment, but it gets dirty quickly and it's difficult not to touch the image with the soiled part of the cloth. Supposedly washable, chamois becomes stiff unless stretched and shaken as it dries. Mine are never effective after they've been washed, but they work well when they're new.

Fresh bread, wadded into a convenient shape, was the first eraser, and it still works. Well into the eighteenth century, until natural rubber replaced it, bread, with the crust

removed, was rubbed into large drawings that were made in preparation for wall paintings.

And finally, a single-edged razor blade is a last resort for gently scraping away surface pastel particles.

ERASING SHIELDS

Made of thin stainless steel, this tool isolates areas of your drawing for erasure. It may have as many as twenty-six cutout openings of different sizes and shapes through which you can do selective precision erasing. Or make your own erasing shield. Simply cut out shapes from an index card for a temporary template suited to the work at hand.

FLOWER LANDSCAPE
Pastel and pastel pencils on paper, 14 × 12" (36 × 31 cm).

This landscape done with soft pastel and pastel pencils on Canson paper is a study of an intimate, hidden corner deep in the woods. The flowers in the foreground are bathed in sunlight and accented to give a feeling of nearness.

Blenders

A blender is any tool that can be used to soften edges or to make a smooth transition between values or colors, a technique known as *sfumato*, derived from the Italian for *smoke*. Erasers can be used as blenders, as can the alternative tools discussed above.

Blending changes the texture of an image. Graphite, charcoal, pastel, and colored pencil all rub across a surface, leaving their pigment on top of the paper fibers. The empty valleys give an airy look to a line or an area of tone or color. Blending pushes the medium into the surface so that the paper's tiny hollows become filled as well, producing colors that seem smoother, more intense, and deeper in value.

While some artists use their hands as blending tools, I do not, and I suggest that you don't, either. Unless your hands are very clean, the oil and sweat on them will make the paper slick. Try the following blending tools instead. They can be used with any of the media discussed in this book.

TORTILLON

A tortillon is a cylinder made of paper rolled into a long, tapered point at one end for blending tiny areas and fine lines. The tip can be cleaned by sanding it lightly. It will be a little fuzzier than it was to begin with, but rubbing it against scrap paper will tighten its point again. When it is covered with particles such as graphite or charcoal powder, it can be used to tone small areas or to delicately grade the values of a form.

BLENDING STUMP

Similar to a tortillon, this cigar-shaped blender, which is also known as a stomp, has a point at one or both ends, but is not as thin and pointy

as a tortillon. Made of compressed paper, felt, or chamois, a stump can have up to a half-inch diameter. An advantage of having a two-ended stump is that one end can be used for blending dark shades of a color, the other for lighter tones.

COLOR SHAPER

Color shapers are rubberlike nibs of different sizes and shapes that come attached to paintbrush handles. There are both white and gray nibs, the white ones being the softer composition, and although they were designed for moving paint around, they are also useful for blending dry media.

PENCIL LENGTHENER

A pencil lengthener makes it possible to use a pencil even when it's ground down to the stump stage. The device holds any pencil of normal diameter. A lengthener for colored pencils, which are expensive, is certainly worth the nominal investment. Koh-I-Noor No. 1098 N has a comfortable wood handle that makes small pieces of pencil easy to hold and control.

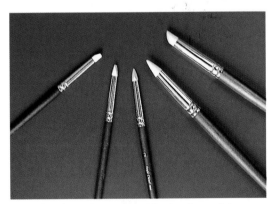

Paint shapers make precision blenders for pastel.

Equipment and Tools

DRAWING BOARD

When someone asks me, "What can I do to improve my work?" I generally respond, "Get a drawing board!" If you use a drawing board, the quality of your work will improve. The drawing board goes under your paper wherever you work. Although most drawing pads are backed with cardboard, it is usually not sturdy or stiff enough. On an easel, a drawing pad will wobble from side to side. On a lap, it will curl over your knee; there is not enough resistance to make a clear, vivid line.

With a drawing board, the stability of the surface makes it possible to gauge the responses that will occur to changes in pressure as the carbon, charcoal, graphite, pastel, or brush glide across the surface. A 2B graphite pencil that is able to make only weak, thin marks on a pad will be able to make from wide and soft light ones to sharp and rich black ones when that pad is supported by a board behind it. With individual sheets of drawing paper, four or five extra ones need to be placed between the board and the working surface to act as a cushion against hardness of the board.

Commercial drawing boards come in various sizes and are made of Masonite. At the top, they have a grip hole to make carrying easier, and a clip to grasp paper.

MAHLSTICK AND ARTIST'S BRIDGE

A mahlstick is simply a long, smooth rod with padding at one end, which the artist holds against the canvas with the nonpainting hand, then rests the other arm on the stick to steady the painting hand. Especially useful for detail work or for long hours at an easel, a homemade mahlstick will also do the job. Just use a curtain rod with a knob of fabric wrapped around one end.

In drawing, it's inevitable that your hand will end up resting on an area of work that has already been started. To prevent smudging, an artist's "bridge" is an effective device to own. A clear plastic shelf with feet, it is placed over your paper, then when you rest the heel of your palm on it, your fingers can continue working while you see through the shelf to the image beneath.

GLOVES

When I'm using water with colored pencils, I sometimes wear gloves to prevent my fingerprints from becoming slick spots on my paper, and gloves are essential if you're using plate-finished paper, acetate, mylar, or dendril. Some artists cut the fingers out of gloves so that only their palms are covered. The gloves they wear are usually the thin, inexpensive kind sold at photography shops.

BIRDS IN FLIGHT
Graphite pencil on paper,
16 × 20" (41 × 51 cm).

The goal of this study was to encourage the illusion of motion by the placement of each individual bird in relation to all of the others.

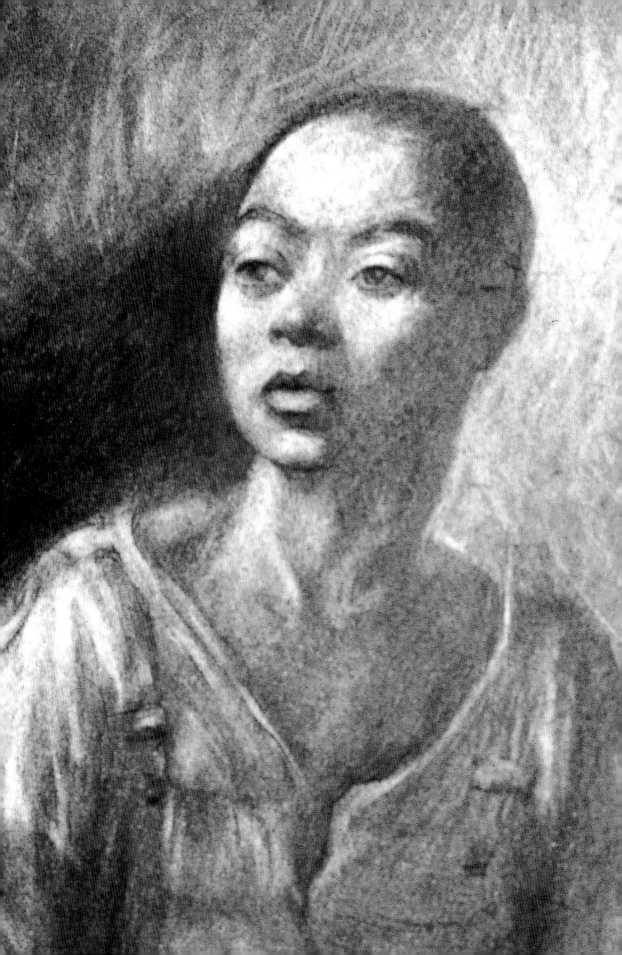

Chapter 6

Demonstrations

If "a picture is worth a thousand words," *doing* what the picture shows is even far more valuable in the learning process, so this chapter shows and tells, in a series of step-by-step demonstrations, wonderful effects for you to try. Consistent with this book's title, I emphasize pencil—particularly graphite and how to achieve painterly results with it.

Of the dozen demonstrations presented, the first ten are dry techniques; the last two are based on wet-pencil painting—one with graphite, and one with water-soluble colored pencils.

In choosing materials to work with as you try the various techniques demonstrated, refer to earlier chapters to find (for example, in Chapter 2) different graphite pencils, papers, and other surfaces to experiment with and various ways to hold those pencils (see Chapter 1) to bring variety and nuance to your work.

ETUDE (DETAIL)
Powdered graphite on paper,
18$^{1}/_{2}$ × 24$^{1}/_{2}$" (46 × 61 cm).

This detail of the pencil painting on page 119 shows the drama and luminosity that is achieved through strong value contrasts. I wanted the atmosphere around the young woman to reflect the tension I sensed in her eyes.

Dry Techniques Using Graphite

One of the drawing techniques that I like best is building layers of tone, as presented in the following exercise that will prepare you for the first demonstration.

Put on your favorite music. Relax. Enjoy the layering process. It's slow, hypnotic, engaging, and you can create surprising, intriguing images with it.

Sharpen your pencil to a point. Make three or four marks on scrap paper, turning your pencil to blunt the tip slightly and evenly. Repeat this procedure often as you work.

Hold your pencil as if you were going to write with it. Place one line parallel and adjacent to the next until a sold area of tone is filled. The natural tendency is to want to begin the second line where the first ended, moving back and forth across the page in a zigzag pattern because that seems faster and easier. But don't do that. If you work that way, the turns at either end will be darker than the space between them. It will become increasingly difficult and time-consuming to even out the differences between the values. Instead, it is important to lift the point at the end of each stroke and begin again in the same direction. With a little practice, your hand will fall into a comfortable, relaxed rhythm, moving smoothly and lightly across the surface of the paper.

Once the first layer is finished, apply the second layer over it. Your pencil strokes can go in the same or a different direction. Whichever way, successive layers will deepen the value richness and the depth of the surface.

As you move across the page, experiment with the atmospheric effect of letting one layer disappear into the next by constantly changing the angles of your lines so that they finally merge without a hint of how they were applied to the paper. Try letting the direction of the marks of each layer remain distinct, so there is a feeling of a constant current of action, of motion under the surface.

See how dark you can make an area by layering it. When you think it's as dark as it can be, you may be surprised to see that you can go even darker, again and again, with the same pencil. The subtlest gradations of values can be totally controlled with seamless transitions or more abrupt ones.

Layering is an alternative way to cover paper with tone without smudging or using a stump. The patience required to layer pays off in the dramatic stage it sets for using other techniques in combination with it to create rich, painterly drawings. See what it can do for you.

Practice pencil strokes to build up your drawing vocabulary. Here are examples of effects produced using various strokes made by a 2B pencil.

RED-FLAG WARNING: As discussed in Chapter 2 (see "Working with Graphite"), this point bears repeating: Beware of the common misconception that shading should be started with light pencils and continued with darker ones. It will lead to trouble! It's like trying to put a flat, water-based paint over a glossy, oil-based paint.

SUCCESS TIP: Instead, use pencils within the same series grade for layering: B, HB, and 2B work well together for building larger areas of deeper tones; use H, 2H, 3H, and 4H in the lighter ones; 4B to 9B are usually best for darkest accents.

BUILDING LAYERS OF TONE WITH GRAPHITE

"Man's Best Friend" was done on Strathmore Bristol, 300 series, smooth, heavyweight, 100-pound paper designed specifically for pencil. Its slick surface will show off very detailed work as well as a rich range of subtly varying values and sensitive lines. It will endure lots of erasing without becoming abraded or changing its response to the graphite. I used Derwent pencils—4H, HB, 2B, and 4B—and did some final touches with a 0.3 mm HB lead in a Koh-I-Noor Rapidomatic holder.

STEP 1. Using a dog's skull for reference, I want to create an intensely observed, carefully constructed drawing on which to base a fully developed pencil painting based on the layering technique. For my initial study to be quite accurate, I search for the longest, continuous straight action lines and the largest, simplest shapes I can find. I try to imagine what two skulls would look like if they were covered with a starched piece of fabric hiding all but the biggest forms, as if it were a secret new car model under a tarpaulin in the designer's showroom. This approach is sometimes called finding the shape of the "envelope."

Then, I slowly divide each line into smaller and smaller straight segments, trying to get progressively more accurate and detailed. Ruling horizontal, vertical, and diagonal construction lines, I constantly check how one point is related to another. My touch is usually very much lighter at this stage so that most of these lines can simply disappear into the shading as the work develops, but here, the lines are more emphatic to make the process easier for you to see.

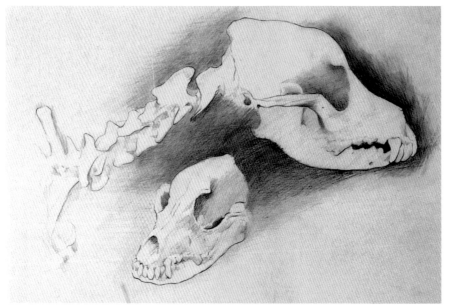

STEP 2. Slowly, I begin to build up shading on the forms and in the value of the background. I aim for the airy atmosphere that results from layer upon layer of graphite patiently applied so that the direction of the lines of each series of strokes disappears completely. My objective is also to make some shapes come forward and some go back in space.

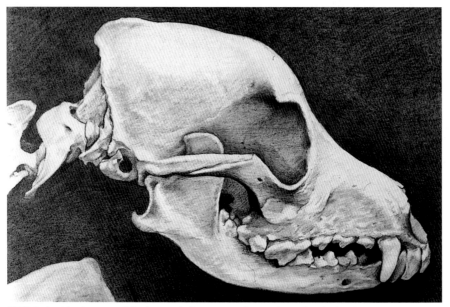

STEP 3. In this close-up of the larger skull, you can observe how details develop naturally as the image evolves from the larger shapes to the smaller ones. By developing the negative space—the background—the positive shapes pop forward even more. Where I want focus on the brightest lights, such as on some of the teeth and the top of the skull, I keep the white of the paper untouched.

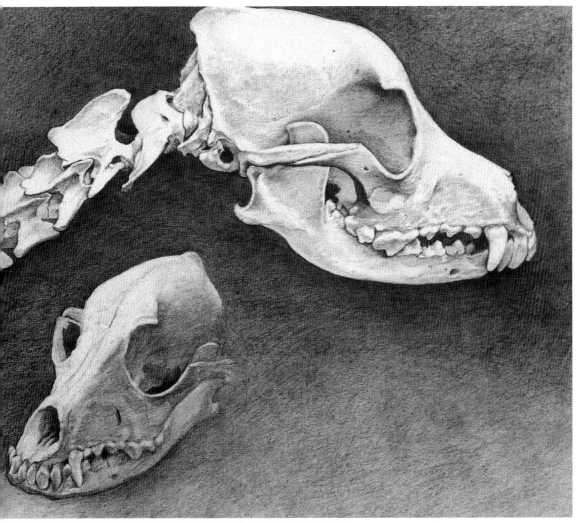

MAN'S BEST FRIEND
Graphite pencil on paper, 16 × 20" (41 × 51 cm).

The bones on the neck and the smaller skull are developed last. Even though my graphite strokes were laid down as numerous individual lines massed in various directions, the layering technique smoothly diffuses them.

Painting with an Eraser

Painting with an eraser is working backward. A drawing is commonly started on a white surface, the darks are added, and the eraser is the tool used mostly to deal with negatives, correcting mistakes. Here, it is all just the reverse. The eraser is used in a very positive way, to create images.

In order to do that, obviously there must be something already on the paper to rub out. It might be a background or a tone of charcoal or powdered graphite rubbed over the surface as a base.

Working with an eraser is working with the light. It is removing the dark to reveal the shapes that are bathed in light. It is similar to a technique used by oil painters called a "rub out" or a "wash in." In that process, the canvas is covered with a transparent glaze of paint, then wiped off while it is still wet, so that the white of the canvas shows through and darker accents are then added using opaque paint. The technique makes it possible to deal with the composition, values, and edges of a painting in a monochromatic way, in preparation for the work in color to follow.

Using an eraser or doing a "wash in" both have a very different look from the one that results from working on a toned canvas or a gray or colored paper. On those surfaces, the lights cannot be lifted off to leave a glazelike tone of the original pigment. The lights must be added with opaque media.

A "rub out" forces you to pay attention to larger forms and to the separation of light and dark in a simplified way. The technique is tonal, not linear. Basic shapes of the composition are considered only as bigger areas of tone. The pattern of lights and darks and how they interact becomes clearer. This concept is called "massing the darks"—regardless of the objects they are flowing over. The dark side of a face might at first be grouped together with dark hair and a dark background as one dark mass to be distinguished as individual entities later in the development of the image.

Understanding and working with the concept of "massing" darks and lights is one of the quickest, most important ways to improve your drawing and painting.

A "rub out" is too awkward a technique for early line or detail work, so it imposes very good habits. Crisp edges and lines can be added later, but since they must be added with deliberate attention, the process leads to greater selectivity and often to a more powerful image.

TYPES OF ERASERS

A lot was written in the previous chapter about the types of erasers available, their characteristics, and their uses. As mentioned there, the perfect eraser doesn't exist, but a kneaded eraser is the one that I use the most because it's so pliable, can be shaped to cover a wide area, squeezed between my fingers into a thin, straight line to make a sharp edge, or rolled to a point to pluck out the highlight in the eye of a portrait.

If my kneaded eraser isn't getting the lights clean enough, or if I need to make an extremely crisp line, I reach for a square-shaped white vinyl eraser, and next, for the cylindrical version that can be sharpened to a point for my smallest, most delicate details.

RED-FLAG WARNING: Look for the method of erasure that will abrade the surface of the paper the least, and try to use the gentlest methods first.

SUCCESS TIP: Snapping your finger on the back or the front of the paper near the problem will release loose charcoal, graphite, or pastel from the surface, and sometimes that is all that is necessary.

Demonstration:
PAINTING WITH AN ERASER

Yes, the art on this page is an extension of the work that you just saw on page 105, but it has grown another skull.

Every time I walked past *Man's Best Friend* resting on my easel, I knew something was missing. It's hard to admit an image isn't working, and harder to risk changing it. The background had taken many, many hours of work and if I altered the carefully graded values, the result could be a total disaster—but the composition felt incomplete. Then I realized that because the lower right quadrant was covered with tone, it gave me a perfect opportunity to paint with an eraser and add a third view of the dog's skull. I knew I had to take a chance.

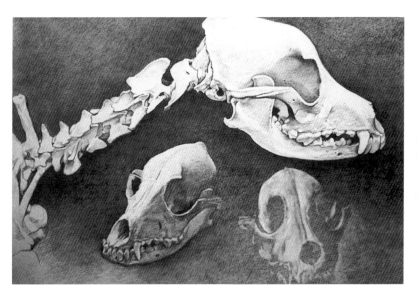

STEP 1. I took a deep breath, picked up my kneaded eraser, and began lifting the lights out of the background where they played on the top and side of the skull. I left the value of the background untouched to allow it to serve as the shadow plane, defining the shape by gently lightening the area behind it.

STEP 2. The worst part was over. As you can see, most of the form of the third skull is already there. The rest is just detail. Part of the magic of the illusion of painting is not how much needs to be there, but how little.

STEP 3. Using HB, 2B, and 4B pencils in the shadow and a 4H in the light, I began to develop the anatomical structures so that the new addition began to look like it belonged with the others.

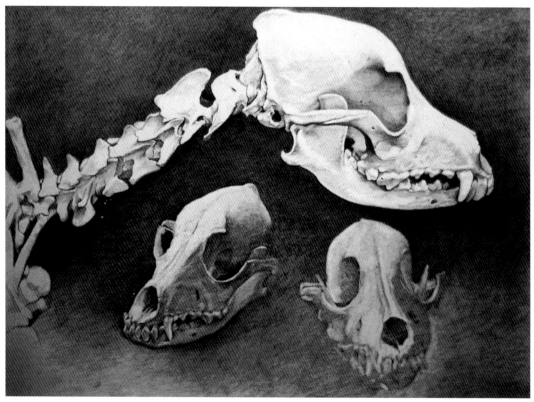

STEP 4. The image was evolving, but it was still not strong enough. I began to think of the relationship of the three skulls to one another in space. How could I make the third one come forward ?

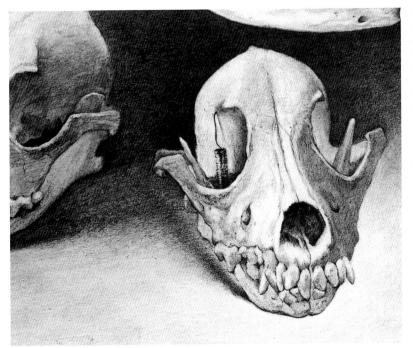

STEP 5. By casting a stronger effect of light on the third skull, a foreground emerged. Although some of the light flowed over the other small skull as well, the most contrast was centered on the third, making it appear more clearly defined and prominent. Cast shadows added another dimension.

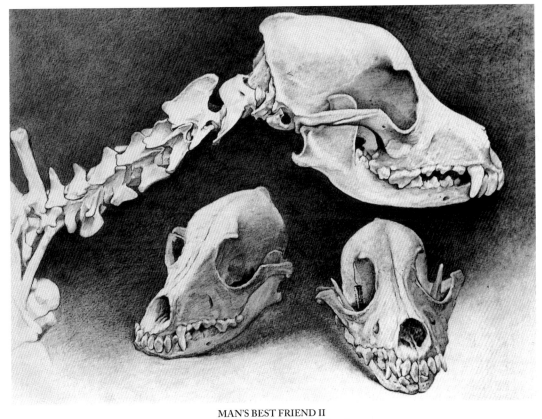

MAN'S BEST FRIEND II
Graphite on paper, 16 × 20" (41 × 51 cm).

The metal spring in the eye of the last skull was an impulsive addition, but it was the final, important accent.

Working with Graphite Powder

Graphite powder (described in Chapter 2) is messy to work with, but it's worth the effort. Any soft rag or sturdy, smooth paper towel can be used to spread a small amount of it, but I like to use Webril Wipes because they have just the right texture for spreading the powder evenly. Once that is done, the grimiest part is over.

In the center is the sandpaper block used to make powdered graphite from 4H, 4B, and 2B pencils. The graphite from the 4H is a little cooler and lighter than the other two when used directly from the pencil in a linear way, but the differences among the three are surprisingly slight once they have been shaved into dust.

A half-teaspoonful of homemade or commercial graphite powder will easily cover an 8 × 10" surface. Facial tissues, paper towels, and toilet tissues (or a cloth rag) are all useful to work with, and a kneaded eraser is a must.

RED-FLAG WARNING: Graphite powder will wipe away almost all of any drawing that is under it.

SUCCESS TIP: Both paper quality and the amount of graphite used determine the value of the tone that results, and with a little experience, it can be predicted and controlled. Lights can be lifted out with an eraser, and darks can be added with layers of pencil strokes.

Dip the cloth into the graphite and be sure to test it on scrap paper to see that it spreads evenly before applying it to your working surface.

It may take a second coat of graphite to cover the surface evenly enough. In most cases, I try to tone the paper to the value of the shadow of the forms I want to create.

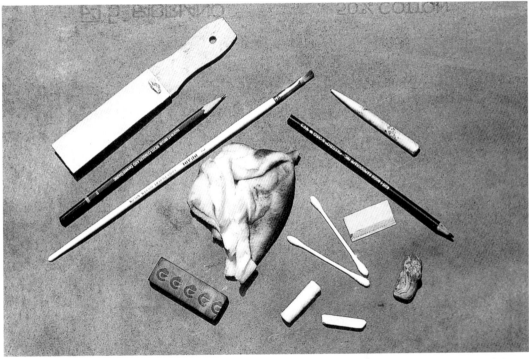

These useful tools each play a role in painting with graphite powder. The cloth with some remaining graphite on it can be used to deepen the value slightly in some places, to darken lights or to eliminate them, reestablishing the original tone so that you can begin again. The cloth's clean spots can be used to pick up extra graphite and to lighten areas.

It's best to start lifting out the lights with a kneaded eraser and to continue using it until it stops lightening

the tones. A plastic eraser will be helpful for highlights. White pastel or Nu-Pastel can be used to accent light areas further.

A brush, Q-Tips, dental swabs, and a stump are all useful for developing subtle variations of values and edges. Use graphite pencils to add crisper lines and to darken shapes. A Koh-I-Noor, "Negro" No. 3 will render even darker darks. General's charcoal white pencil will give you the brightest lights.

Demonstration:
CREATING THE ILLUSION OF ROUNDNESS

Transforming a round shape into a sphere with volume is essential not only for depicting oranges and beach balls, but for creating portraits of the human face, as the next demonstrations illustrate. We start with the sphere itself.

STEP 1. Left: On my fully toned ground, I use a kneaded eraser to pull out light on the form.

Right: As I lighten the background to reveal the shape of the shadow, the illusion of a ball appears, resting on a surface, indicated by the slight cast shadow that I've also created with my eraser.

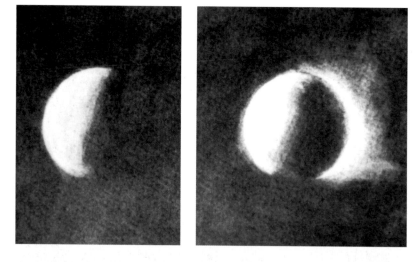

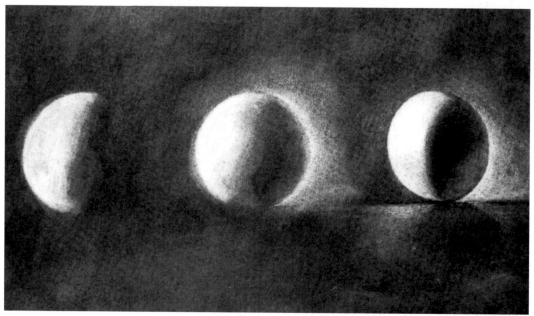

STEP 2. Left: Where the light on the ball stops because the sphere starts curving back away from its range, both the light and the dark are the strongest. That edge was first made crisper and lighter with the eraser in the light areas and subtly darkened with a "Negro" No. 3 pencil in the dark.

Center: Now the shadow on the form is darker near the light and slightly less dark where light is bouncing back from the tabletop and can be seen reflected on it. The table was gently lightened, leaving the original tone to define the cast shadow further.

Right: A sharpened pencil point was used to make a dark accent at the place where the bottom of the ball rests on the surface. The illusion of roundness was heightened by adding a highlight in the upper section of the light with a white Nu-Pastel.

112

Demonstration:
TURNING A BALL INTO AN EYE

Even though human eyes vary widely in shape, the eyeball is always a sphere, resting in a socket, and the best way to practice drawing and painting the human eye is to start with a round shape, then draw details over its form.

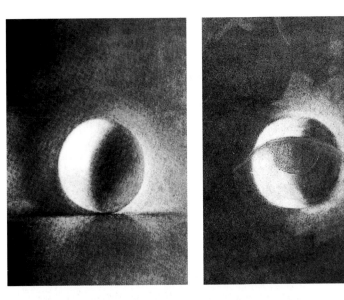

STEP 1. Left: The sphere of the previous demonstration is my starting point. Right: I begin defining the ledge of the upper lid and the shadow it casts on the eyeball. Then I add the shape of the pupil under it.

STEP 2. Using a kneaded eraser to make a slightly curved erasure sliver, I depict the way the lower lid catches light. Note, too, how the lower lid cuts off the bottom of the pupil—usually the case unless the eye is open very wide in surprise or is looking upward. I make the pupil as dark as the medium can make it. With light coming from the upper left, using a pointed eraser, I locate a round highlight on the iris, next to the pupil, and a curved highlight at the lower right on the iris, where it emphasizes the "catch light."

STEP 3. Here the lights are intensified with white NuPastel applied to the upper lid, rim of the lower lid, and to brighten still more the dot of light on the iris.

Note that the "whites" of the eyes are usually not white. Instead of using white for eyeballs, choose a tone that is pinkish, grayish, or bluish.

Demonstration:
CREATING THE MOUTH

The lower part of the face, from under the nose to the chin, can be seen as a sphere on which the philtrum (that vertical groove between nose and mouth), the lips, and the chin are developed in drawing or painting a portrait.

STEP 1. On a toned ground prepared with graphite powder, using my kneaded eraser, I define the groove above the mouth by lightening around it on the left and right, thereby giving depth to the groove itself through the value contrast I create.

STEP 2. I develop the lower lip by lightening it considerably in relation to the upper lip. The shadow under the lower lip begins to define that slope.

STEP 3. Because the upper lip rests on the lower lip, it casts a shadow on it. But light also plays on the lower lip because its fullness faces upward. Note that I've darkened the ground more to help focus on the developing image.

STEP 4. For purposes of this demonstration, the shape emerging under the lips is exaggerated to emphasize that the center of the chin begins as another sphere and is later modified.

STEP 5. I dot final light highlights here and there along the rim of the upper lip and darken other areas of the upper lip to establish even more contrast between it and the lower lip.

Demonstration:
GRAPHITE PORTRAIT PAINTING

After making studies of individual features, when you're ready to tackle a full portrait by painting with an eraser, begin by preparing a ground, using either of the methods shown earlier: layering tone with graphite pencil or spreading graphite powder.

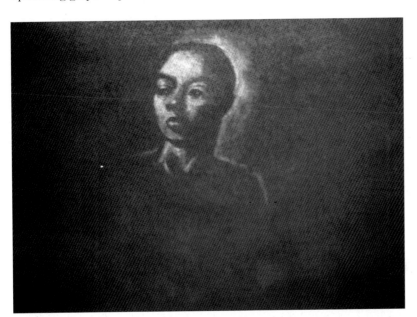

STEP 1. On 100-percent cotton rag paper, I prepared the ground by spreading graphite powder, toning it to about the value of the shadows on the figure. With a kneaded eraser, I start the head in the same way as I had begun the sphere, the eye, and the mouth, by lifting out shapes of light on the face. Next, I define the outline of the model's hair by lightening the background.

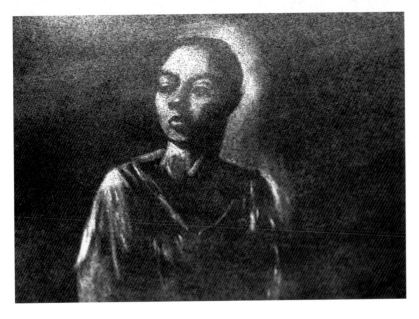

STEP 2. Working down from the head, I create the bodice of the dress, rubbing out the lightest tones at the shoulders to establish the body's contour.

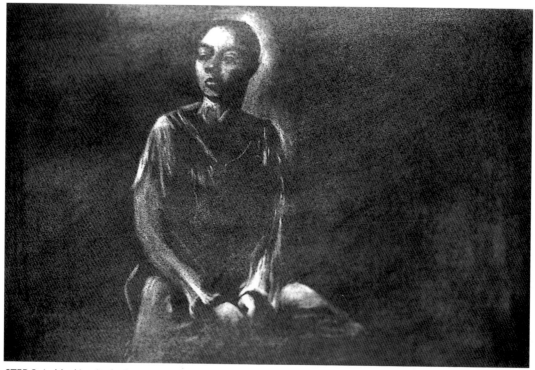

STEP 3. In blocking in the lower part of the figure, I lift off shapes of light to indicate the model's arms and hands resting on her lap.

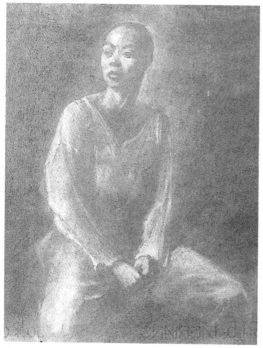

STEP 4. Keeping my light source consistently coming in from the left, I lift off a long, vertical path of graphite that further defines and contours the model's arms and legs. I lighten her neck as well.

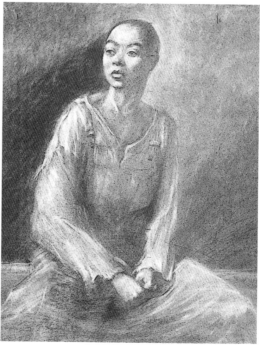

STEP 5. Now a burst of air seems to come in from upper left as I rub out a swath of light on that side, using a vinyl eraser, casting additional light on several areas of the dress to suggest its folds and flimsy texture.

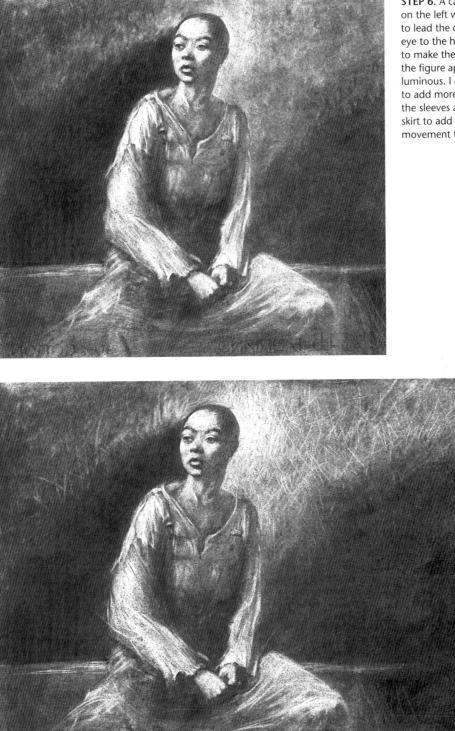

STEP 6. A cast shadow on the left was added to lead the observer's eye to the head and to make the lights on the figure appear more luminous. I decided to add more sweep to the sleeves and the skirt to add drama and movement to the pose.

ETUDE
Powdered graphite on paper, $18^{1}/_{2} \times 24^{1}/_{2}$" ($46 \times 61$ cm).

With the corners and edges of a vinyl eraser, I add more texture to the background to complete the painting.

Frottage Technique

From the French word for "rubbing," *frottage* is the process of reproducing a raised (high-relief) or impressed (low-relief) image or texture by placing a piece of paper over it and making a rubbing. It is most commonly associated with the centuries-old practice of taking rubbings with charcoal, pencil, chalk, or crayon to record impressions of names and dates engraved on tombstones.

Surrealist artists, particularly Max Ernst, experimented with the technique in the 1920s, using it as a starting point to explore the pictures his subconscious found in shapes and images he perceived in frottage textures. He also used oil paint on canvas laid over objects such as textured glass, string, wood, and metal grates, calling that process *grattage*.

In recent years, frottage has been used extensively by contemporary artist Sari Dienes, who takes her rubbings from manhole covers.

LAYERED FROTTAGE

Rubbings can add interesting dimension or intricate detail to just one area of an image or the technique can be used for an entire work. When applied in layers of different values and media, in black and white and/or color, the results are even more intriguing.

In addition to working with the examples shown on these pages, make your own experiments. Try different kinds of paper, placing them over various wood grains, woven fabrics, lace, and other textures that lend themselves to this drawing and painting technique.

This close-up photograph of the bench seat from which I took my rubbing shows the excellent texture that wicker offers for this technique. It has a wonderful pattern and rough surface, yet there are no pointed edges that might make holes in the paper when it is placed over it for the rubbing.

Demonstration:
WICKER RUBBING

For this demonstration and the two that immediately follow it, I used powdered graphite to capture the delicate textures of low-relief surfaces, applying the powder as a first layer on bond paper over textures which I then rubbed a second time with a kneaded eraser and a third time with white Nu-Pastel to highlight the top ridges of the surfaces for an additional illusion of depth.

STEP 1. Using a medium-weight sketching paper taped in place over the center of the wicker pattern, after I rubbed powdered graphite with a soft paper towel gently over the surface, the image began to emerge.

STEP 2. To darken some areas, I rubbed the surface again, using a soft 9B Derwent pencil. To lighten other areas, with a kneaded eraser I glazed across the topmost parts on which the paper rested, then used white colored pencil on those peak spots.

WICKER
Powdered graphite on paper, 20 × 24" (51 × 61 cm).

My last application are touches of soft white pastel to add further depth and an illusion of motion.

Demonstration:
BRICK RUBBING

Brick is one of the most perfect surfaces for frottage work. Given the varying configurations in which brick is laid, many different patterns can be derived from their rubbings. This particular one is from a kitchen floor. While natural brick offers the best surface for a rubbing, some imitation brick wall siding also has good three-dimensional texturing potential.

STEP 1. Powdered graphite established the tone in my first rubbing, which was made on bond paper. Then I used a kneaded eraser to accentuate the highest points of the brick surface.

STEP 2. I alternated layers of graphite with erasure rubbings several times to capture the inherent unevenness that is characteristic of a brick finish.

BRICK KITCHEN FLOOR
Powdered graphite on paper, 20 × 24" (51 × 61 cm).

For my final accent, the swath of diagonal light that seems to play on the brick is deliberately placed to enliven the pattern.

Demonstration:
ANTIQUE TABLECLOTH RUBBING

Many kinds of fabrics are fine candidates for
frottage work. Cloth with wide weaves in rough
textures such as burlap are fun to experiment
with, using crayon. Other good fabrics to try,
using pencil, are those that have decorative
openings, such as fine eyelet holes, or raised
threads, in a delicate embroidery pattern.

STEP 1. The delicacy of
this antique tablecloth
caught my eye the
moment I saw it. Its
intricate pattern of tiny,
open cutwork and
fine raised embroidery
promised to produce a
rich rubbing. The first
layer of graphite just
began to capture its
wonderful texture, as
seen in this detail.

STEP 2. This detail shows
the layers of 2B pencil
that I used in the fabrics's
flat areas to bring out its
fine weave, and white
Nu-Pastel on the raised
areas to bring out its
embroidered design
more crisply.

ANTIQUE TABLECLOTH
Powdered graphite on paper, 24 × 20" (61 × 51 cm).

In my finished composition, note that wherever there's a white peak, a dark valley next to it or surrounding it adds to the realistic, tactile quality that I tried to achieve, hoping to tempt the viewer to run fingers over the surface to see if it's *really* raised.

Demonstration:
BURNISHING

Polishing pigment into the surface of paper is the process known as burnishing. Because every paper, no matter how smooth, has some "tooth" (explained under "Paper" at the end of Chapter 2), the rougher the peaks and valleys, the more difficult it is to force tone into the crevices. Sometimes a beautiful effect develops naturally because of the nature of the paper's texture, but sometimes it gets in the way of making the darks as intense as you want them.

Burnishing can be accomplished with any tool that presses the medium you're using—graphite, charcoal, colored pencils, or pastel pencils—evenly into your working surface. Burnishing tools include blending stumps (see "Supplemental Materials"), spoons, candles, and my preferred method for graphite, as used in this demonstration, rubbing a harder pencil over a softer one, which produces a very rich, velvety-black finish.

STEP 1. On smooth printing paper, I begin at the heart of the image, using 2B and 4B pencils to draw the lively reflection I see gleaming on the side of a kettle in my kitchen.

STEP 2. To contain my initial drawing, I outline the kettle and its lid, then enlarge the reflection pattern of intricate lights and darks. I do not attempt yet to make the values as dark as they eventually will become.

STEP 3. Alternating between starting new areas with my 2B and 4B pencils and returning to established ones, I deepen their values by burnishing the darks with an HB pencil.

STEP 4. With the lid and the spout more fully described now, I begin to establish the handle of the kettle and introduce shadows under it. As the darks deepen, the lights seem to glow.

Working with graphite is bound to leave smudges on the margins of my paper, but I don't worry about them at this point. I erase minimally when I'm immersed in creating a pencil painting, leaving my cleanup for last.

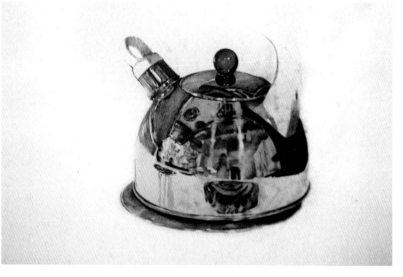

STEP 5. This detailed close-up emphasizes how light plays on metal in dramatic and varying ways. Note how it is subtler on the knob of the lid.

STEP 6. The rich visual material that can be found in reflections—these shapes of reality that wrap around the form of the belly of the pot—are seen in this detail.

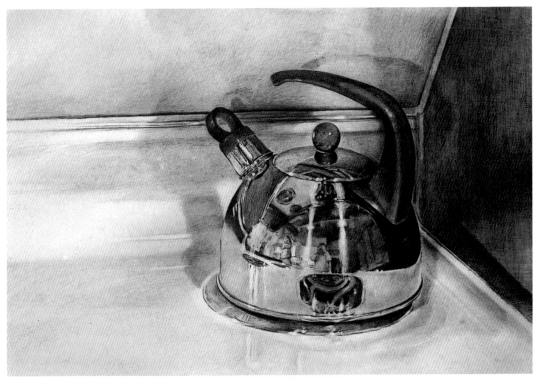

STEP 7. Deciding to give my kettle a setting, I add the stovetop and background, working in shadows that the kettle casts on them.

Evolution of an Image

My kettle on the previous pages started as a demonstration on burnishing, but evolved into a very different image. I had been thinking about levels of meaning as seen in the kitchen reflections on the kettle's shiny contours. That led to my thinking about the illusion of depth. Soon I began picturing the kettle through a window. Then the idea of a shattered window on the surface of the picture plane began to grow.

In this detail of a windshield wiper on top of a section of shattered window, through the window you can still see part of the stovetop of Step 7. I again employed the services of 2B, 4B, and HB pencils to render, then deepen, the minutely detailed pattern of shattered glass.

BOILING POT
Pencil on printing paper, 26 × 38" (66 × 97 cm).

An unexpected element completes this pencil painting when I add an organ keyboard across the foreground. Then I develop the windshield wiper and shattered glass still further, burnishing the darkest areas to lend more contrast.

Wet Techniques Using Graphite

Various graphite pencils that are water-soluble were reviewed in Chapter 2. They can all be used both dry or wet. For purposes of the next demonstration, a good choice is the Derwent Sketching Pencil in HB or "light wash," 4B or "medium wash," and 8B or "dark wash." When they are used dry, all three produce equally rich velvety blacks and delicate light grays. The 8B is softer, smoother, and easier to apply than the other two. It reveals more of the texture of the surface as well, but it doesn't make any darker mark than the others.

When graphite pencil marks are brushed with water, all three grades can be used to create a light, medium, or dark tone. The lines made by the HB remain more crisply visible than the ones made by the 4B or the 8B. When the tips of all three are dipped in water and used, they make a similar value of blacker black. The points remain fairly firm and they can be sharpened with any standard sharpener. Rubbing a brush on the graphite picks up less tone than can be easily lifted by applying dry graphite to scrap paper and using it as a palette.

ERASING WATER-SOLUBLE GRAPHITE
Water-soluble pencils are erasable when used dry or when they have dried after being used as a wash. If a kneaded eraser doesn't lift enough graphite, try one of the others shown in the photo on page 131. Your last resort could be the Eberhard Faber Union eraser used on its white side.

USING BRUSHES WITH WATER-SOLUBLE GRAPHITE
A soft brush designed for ink, watercolor, or acrylic paint will work with water-soluble graphite as well. By dipping the brush in water and then moving it gently across dry graphite lines on the surface of an image, the pigment will dissolve into a wash of tone. It takes a little practice to anticipate how much graphite will be picked up by the brush. The strokes dry rapidly, but you can wet them again and rework an area.

It's useful to have several sizes and types of brushes. Brushes with pointed tips are called rounds; flats have a long, flat, square shape; brights are modified flats, with shorter, stubbier bristles; filberts have a flat shape with rounded corners. Each produces its own characteristic stroke. A fan-shaped brush is good for special blending effects (such as depicting hair or sprays of water on a breaking wave).

RED-FLAG WARNING: On a slippery, nonabsorbent surface, a brush tends to work like an eraser, removing, rather than applying, pigment.

SUCCESS TIP: Avoid disasters occurring when you pencil paint by practicing first with different types of brushes. As is true when we use pencils, each of us has our own distinctive "handwriting" when we manipulate brushes. Learning what different shapes of brushes can do when the results are not crucial helps to reveal the kinds of strokes that are truly yours.

From left to right, the erasers pictured are kneaded, Eberhard Faber Pink Pearl, Staedtler Mars Plastic, and Eberhard Faber Union. The pencils are Derwent Sketching Pencils 8B, 4B, and HB, and the brush is a Winsor & Newton No. 7 series 233.

These Winsor & Newton Galeria nylon brushes are designed to be used with all water-based media. Similar shapes and sizes of brushes made with hog or sable hair can be used with turpentine or water. From left to right, the first five brushes are rounds, ranging from the largest, number 12, to the smallest, 0. Next is a fan brush, then two filberts, two flats, and two brights.

Preparing to Make Waves

In preparation for our next demonstration, these exercises are an introduction to *Making Waves.*

Waves can be thought of as a series of steps on a very uneven staircase—except that waves are not solid; light flows through translucent water. When the sun is behind the water, backlight on waves makes them brighter where sunlight glows through them.

Referring to the staircase in the sketch, the riser of each step faces up and the kick plate faces front. In normal lighting from above, the top plane is light and the side plane dark. Similarly, waves have an under plane, a place that faces down away from the light at its base, and waves are darkest there.

With stairs, the top edge where the two planes meet is where the lightest and the darkest values meet. Sometimes light bounces up from the top of the next lower step and reflects into the bottom of the shadowed plane, lightening it slightly. Often the higher step blocks the light falling on the lower one, causing a "cast shadow" to fall on it.

Obviously, waves are not geometric, but it helps to think of them as simple shapes to understand their complex forms and how to light them. Thinking about the profile of a wave helps to distinguish the characteristics of the constantly shifting patterns of movement.

Demonstration:
WATER-SOLUBLE GRAPHITE

STEP 1. On illustration board, I make the location of the highest wave the focal point of my composition. I use a 4B pencil, dry at its base and wet at its point, making the wave darker at its peak and slightly lighter beneath it, to indicate the translucent light glowing through the water from the backlight of the sun low on the horizon behind it.

STEP 2. Next, I establish the pattern of the rows of waves by indicating some of the foam of the next one, and the dark at the base of the closest one. The line of the buoy was used to counterbalance the diagonal composition. Creating some wavelets in front of the buoy line suggests a low vantage point.

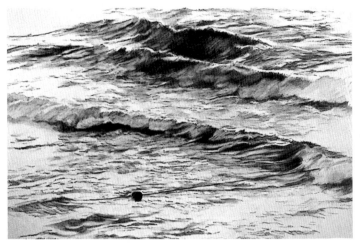

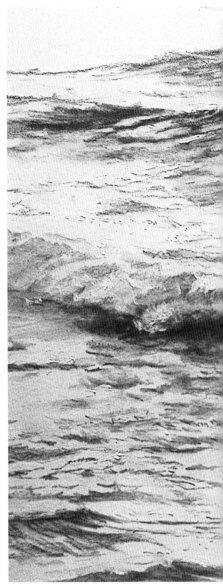

STEP 3. More details are added to complement the established composition. I strengthen the darks with more tone and, using a brush dampened with water, enhance many dry pencil strokes.

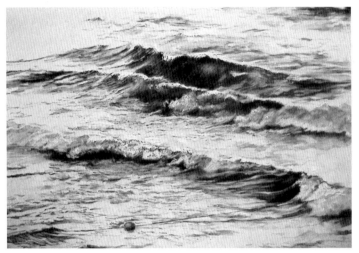

STEP 4. I work more dry pencil strokes on top of and into the washes of tone. Tiny dark and light accents suggest the sun's sparkle bouncing on the water. My highlights are made by dipping a white colored pencil in water, which softens it, then applying it to the paper thickly.

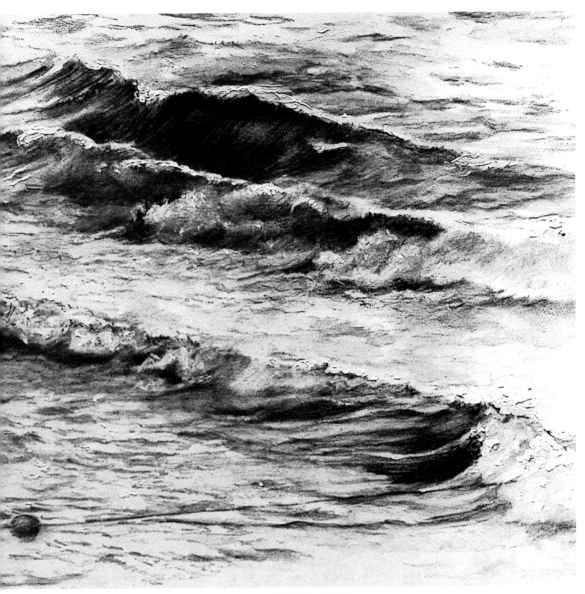

MAKING WAVES
Water-soluble graphite on illustration board, 11 × 15" (28 × 38 cm).

My last dark strokes are applied with an 8B pencil softened in water, then I dab on tiny dabs of white gouache for final light accents.

Using Water-Soluble Colored Pencils

When water-soluble colored pencils are used dry, the pigment is rubbed off by the texture of the surface to which they are applied. If a line drawn with colored pencil were magnified, it would look like a series of dots caught on the tops of the paper fibers. Each dot would be opaque, but the color of the surface would be apparent between them. The color that is seen is the result of the hue applied mixed with the color of the ground it is resting on. If several layers of colored pencil pigment are applied, the color that is created is the result of the eye blending them together—optical blending. Enlarged, a layer of blue and a layer of yellow on white will remain individual dots of color.

When water is used with soluble colored pencils, the pigments dissolve. The wet color flows evenly over the surface, covering all of it. The ground color glows through washes of transparent color. Two hues, blue and yellow mixed together, will form a green wash.

The same pigment dissolved in water will look more intense, more vibrant than

it appeared applied dry. A more intense hue will also often seem to be lighter in value.

Water-soluble colored pencils can be used as thick, semimoist impasto accents by dipping their tips in water until they soften, then begin working with them.

In terms of surfaces, when colored pencils are used wet, the underlying color of the paper used affects all of the transparent colors washed over it.

ERASING WATER-SOLUBLE COLORED PENCIL

Normal erasing techniques are not very effective with dry colored pencils. Rubbing with any eraser just smears the pigments and pushes them further into the surface. Once colored pencil pigments have been dissolved and allowed to dry, an eraser that works by rubbing will do less to change the look of the surface and will remove some, though not necessarily all, of the color. It's easier to lift the color by diluting it with more water.

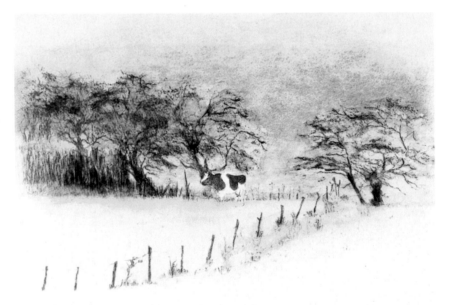

COW IN THE MEADOW
Colored pencils on paper, 10 × 12" (25 × 31 cm).

This pencil painting was enhanced with water. It's so easy to carry water-soluble colored pencils, a small brush, and a little jar of water in a tote bag, so that you're always ready to paint small countryside landscape images or other vignettes that inspire you.

Demonstration:
WATER-SOLUBLE COLORED PENCILS

STEP 1. This detail shows how I begin a painting of a night sky, using water-soluble colored pencils on photographer's black mounting board. Starting in the upper left quadrant, I leave some of the black surface untouched to represent a mountain slope and trees silhouetted against the sky, which I begin to lighten with a water-resistant brand, Studio Colored Pencils.

STEP 2. Working with blue, yellow, and white, by beginning with water-resistant colors, I'll be able to apply washes later without losing the shapes being created during this early stage of the painting. Burnt umber and black are added to darken and give texture to the trees.

STEP 3. Changing to Derwent Watercolor Pencils, I begin to use warmer blues with water for the sky, and Chinese white, French gray, sky blue, blue gray, red violet lake, rose pink, burnt umber, and black for the clouds, alternating between wet and dry strokes.

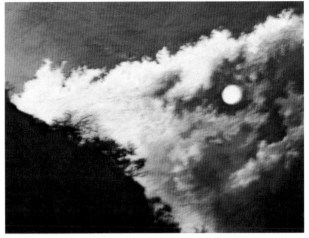

STEP 4. Now focusing on the painting's lower right quadrant, where a full moon breaks through the clouds, this detail shows my introduction of Caran d'Ache water-soluble Neocolor 11 painting crayons—light gray and white softened with water and applied thickly to the puffy edges of the clouds.

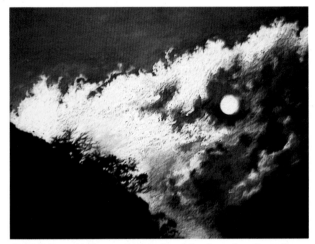

STEP 5. For added warmth, I apply a thin glaze of an "eggy" yellow and a cooler yellow.

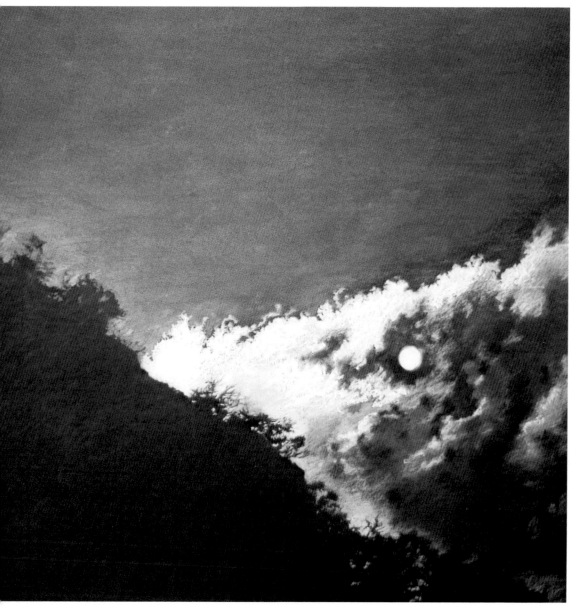

MOONLIGHT
Water-soluble colored pencil on photographer's black mounting board, 14 × 18" (36 × 46 cm).

Afterword

The contrast between working from observation versus imagination was highlighted by a fascinating story that Peter Falk, so popularly known as Colombo, told me in explaining why he began to study art as an adult.

When Peter was a child, he and a friend loved to draw all of the time, but Peter eventually gave it up because he thought his friend was the only talented one of the pair. His friend could draw all sorts of things from his imagination—battleships, guns, beautiful girls—but Peter could only draw what he saw.

One day many years later when Peter was sitting around for hours of boring downtime on a film set, he began to draw an old suitcase that was resting near his feet. Another actor came by and was very impressed by the sketch he saw. Peter said that it was nothing, because he was only drawing what he was looking at. His companion responded that artists have been trying to do that from the beginning of the history of art.

When Peter returned to New York, he went to the Art Students League to study anatomy and drawing in a class where students worked from direct observation. Peter's childhood friend had done drawings based on verbal symbols created in his imagination. Peter's inspiration came from a visual, nonverbal response to the world around him. They are very different ways of working, emanating from very different ways of thinking.

Verbal images are mental constructs. A verbal image is a pictograph or a highly simplified symbol of an object or an action. They are easier to make up, to remember, and to play with in our imagination. It is much more difficult if not impossible to remember all the subtleties of a visual image. It is easier to remember and reproduce the face of Batman than it is to create a likeness of your mother.

One way is not better than the other. Some artists prefer working from observation; others prefer working from imagination. Whichever you choose, it's interesting to try both. It's always difficult to try something new, but it's also exciting.

WORDS
Colored pencils and
markers on aged newsprint,
sprayed with water,
16 × 20" (41 × 51 cm).

This painting was inspired
by words heard often
in songs played on late-
night radio. Sometimes
surprising images emerge
when you let them.

WORKING FROM IMAGINATION

If you've never worked from pure imagination, don't expect to be able to do it as well as those who have been practicing all their lives, but you can do it if you try, and if you keep trying, your work and your imagination will blossom. There are several ways to begin.

Try doodling. Try starting with an ink blot. Try keeping a sketchbook just for nonsense. Try illustrating your favorite song. Try turning a young face into an old one, a man into his sister, a parent into a baby. Imagine the reflection of the model in a distorted mirror. Try putting the eyes of one person with the nose and mouth of another. Find a description of a fictional character in a book, one who has never been brought to life on film, and create that person's portrait.

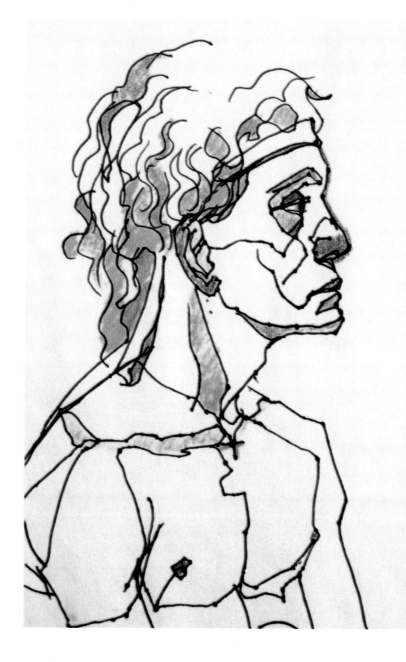

CONTOUR DRAWING OF A MAN
Pencil with crayon on paper,
24 × 18" (61 × 46 cm).

This is a contour study in which I gave the enclosed areas of shapes some touches of color to emphasize their decorative patterns.

AN EXERCISE TO STIMULATE IMAGINATION

Try making up an animal. Leonardo da Vinci tells us how. He advises that "if you wish to make your imaginary animal seem natural, let us say it was a serpent, take for the head that of a mastiff or a hound, the eyes of a cat, the ears of a porcupine, the nose of a greyhound, the brow of a lion, the temples of an old cock, and the neck of a turtle."

ANOTHER WORLD NO. 1
Colored pencils and markers on aged newsprint, sprayed with water, 16 × 20" (41 × 51 cm).

Index

ABOUT THE AUTHOR

Based in Pleasantville, New York, and Manhattan, **Sherry Wallerstein Camhy** is on the faculty of the School of Visual Arts and the Art Students League. Her acclaimed courses include drawing, painting, portraiture, and human and animal anatomy.

A versatile, prize-winning artist who is often awarded for her drawings, paintings, graphics, and pastels, Camhy has been honored by the National Arts Club, Hudson Valley Art Association, Catherine Lorillard Wolfe Club, Salmagundi Club, and is also a recipient of the Elliot Laskin Award for sculpture. Her work is included in fine corporate and private collections and has been exhibited by museums and other venues in many parts of the United States and abroad, including the Israel Museum, Santa Barbara Museum of Natural History, Hammond Museum, Katonah Museum, Montclair Museum, the Los Angeles International Print Association, Lever House,

and Audubon Artists Show. In New York, where her work has been represented by the Frank Caro Gallery, she had a solo show at Pace University, and her retrospective inaugurated the opening of the Peter Fingesten Gallery.

Camhy holds a Master's Degree in Art Education from Columbia University, and studied anatomy at New York University Medical School, dissecting cadavers and passing exams along with students preparing to be medical doctors. As a student at the Art Students League, where she won three Concours awards in drawing, a Merit Scholarship for sculpture, and a League Scholarship for painting, she was a monitor for Robert Beverly Hale and Harvey Dinnerstein, and also studied with Ethel Katz, Gustav Rehberger, David Leffel, Daniel Greene, and Ted Seth Jacobs. Her work with Caesar Borgea, Stephen Rogers Peck, and Burton Silverman also contributed substantially to her development as an artist.